A BRIEF HISTORY *of*

FAIRPLAY

LINDA BJORKLUND

Charleston — London

THE
History
PRESS

Published by The History Press
Charleston, SC 29403
www.historypress.net

Front cover, top: Mount Silverheels in autumn. *Courtesy of Bernie Nagy, High Country Artworks.*
Front cover, bottom: Early 1900s firemen. *Courtesy of South Park Historical Society.*
Back cover, top: Kids on burros. *Courtesy of Dan Abbott.*
Back cover, bottom: Front Street, 1880s. *From the Ed and Nancy Bathke Collection.*

First published 2013

Manufactured in the United States

ISBN 978.1.60949.955.6

Library of Congress CIP data applied for.

CONTENTS

CONTENTS

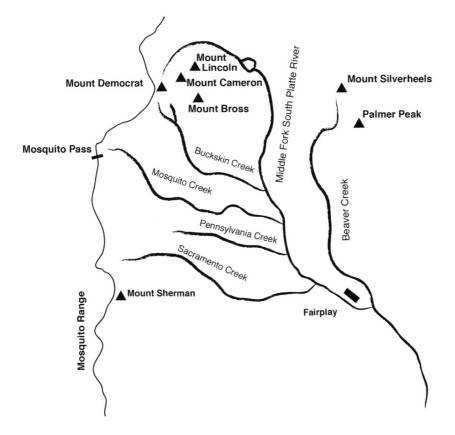

Mountain peaks and rivers near Fairplay. *Drawing by author.*

IN THE BEGINNING

Nestled at the base of several mountain peaks, the town of Fairplay gives little evidence of the millions of years of its past that created the setting. But there are a few clues that tell us how the stark ruggedness of the terrain came to be. A large, rounded boulder in Cohen Park speaks of mountain building and erosion. Meandering rivers and creeks tell how valleys were cut through the mountains towering above them, their downward flow carrying minerals from higher places after having been forced upward out of niches and crevices deep underground.

Planet earth is generally aged at about 4.6 billion years old. Colorado has been around for about 2.5 billion of those years. Since our viewpoint as humans can cover but a tiny speck in the overall time span, we can only speculate on the grandiosity of the relatively slow changes in the tiny portion of ground that we call home. And the wonder of it all is—the earth is still changing.

Geologists use the term "plate tectonics" to describe how the earth's surface has evolved from a near sea-level crust to the extreme heights and depths that we have today.

The earth's inner core is made up of solid iron; the outer core that surrounds it is liquid iron and nickel. Around the core is a mantle that is partly molten and partly solid. The uppermost mantle and the crust above it are solid. The surface crust is composed of a dozen plates, each around sixty miles thick. These plates have periodically rearranged themselves—separating and crashing into one another—to form different landmasses and oceans.

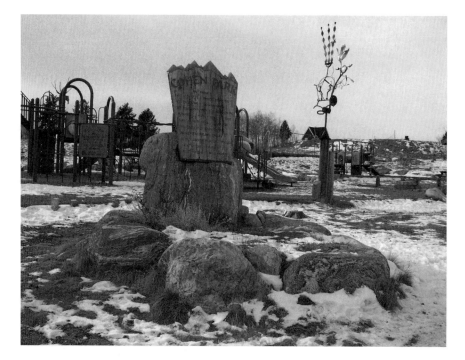

Cohen Park. *Photo by author.*

The earliest period of the earth's history has been labeled Precambrian. Most of the Precambrian rock in Colorado, known as "basement rock," was formed as a result of several collisions of plates, followed by the earth's crust pulling apart at weak zones, allowing sediment to build up in lower areas. There are few fossils from this era simply because the only known form of life was archaea—one-celled microorganisms. The landmass that we now know as Colorado originated south of the equator and thousands of miles to the east.

During the next era in earth's history—the Paleozoic—a supercontinent that has been named Pangaea was formed. Pangaea contained what later became Eurasia, North America, South America, Africa, India, Antarctica and Australia. By this time, the landmass that would become Colorado had moved in a counterclockwise direction and was located just north of the equator and many miles to the west.

The sea advanced and retreated a number of times during the Paleozoic era, bringing with it ancient forms of life from early invertebrates evolving into fish and, later, amphibians. Evaporation of the sea left deposits of salt and limestone.

Late in this era, the Ancestral Rockies were formed. Another term that geologists use is "orogeny," which is an event that results in mountain building. The uplift or orogeny that created the early mountains forced Precambrian rock upward through the layers of limestone left by the sea. Throughout the rest of the Paleozoic era, the ancestral mountains gradually eroded into gravel.

It was during the next era, the Mesozoic, that Colorado's character began its formation. Dinosaurs ruled the land, which was lush with vegetation. Flourishing plant life became the basis for the formation of coal. Thick sand changed to shale in layers that trapped marine animals, whose fossils were entombed.

Then, late in the Mesozoic era, several things happened—not quickly but simultaneously. Volcanoes as near as the Thirtynine Mile Mountain and the San Juan Range began to erupt, sending ash through the air to cover the upper surfaces and magma through the faults and crevices of the underground crust. The sea had expanded and then receded as the land began to rise due to a new major mountain-building episode now labeled the "Laramide Orogeny." The earth's plates pushed against one another and forced the land upward in the same general pattern as the Ancestral Rockies. Although the newly formed Rocky Mountains were twenty thousand feet above sea level, they too have suffered the erosion that happened to the Ancestral Rockies. Fourteen-thousand-foot peaks still, however, seem grandiose to the humans who try to conquer them.

As hot magma was forced through underground fissures and openings, mineral deposits were carried upward by hot, gaseous waters and released when the gases disbursed and the water cooled. This created an area that came to be known as the Colorado Mineral Belt, as it is the source of the gold, silver, lead, zinc, copper and other minerals that brought prospectors and miners to the state of Colorado.

Another and more cataclysmic event that occurred late in the Mesozoic era was not discovered until recently. Scientists were puzzled about the relatively sudden disappearance of the dinosaur population until evidence of a meteorite hitting the earth was uncovered. A pattern of ash containing the substance iridium, rare on earth but abundant in meteorites, was found centering from a location in Mexico's Yucatan Peninsula. The collision resulting in extreme heat radiating from the site would have killed everything above ground for many thousands of miles. The latter part of the Mesozoic era also marked the splitting away of continents from Pangaea and the rearrangement of oceans that surround them.

The final era, and the one that we are still in, is the Cenezoic. The seas retreated for the final time as this era began. Cyclical cooling of the climate, especially in the high altitudes of the Colorado Rockies, created two glacial periods. The town of Fairplay shows evidence of glacial deposits and is, in fact, on the edge of a terminal moraine left by the later glacial period. A "terminal moraine" is, simply put, a pile of rocks left by melting snow runoff alternating with re-advancement of glaciers and then more melting.

After the dinosaurs became extinct, mammals flourished. Remains have been found of woolly mammoths, camels and an early type of horse about the size of a dog. Later came the bison, coyotes, bear, beaver and other mammals that attracted the initial migration of humans. But it was the mineral deposits—the gold in "them thar hills"—that brought them in droves.

Chapter 2
MAMMALS AND PEOPLE

The narrow strip of land known as the Bering Strait, located between Alaska and the Siberian Steppes, was a scene of eastward migration as the Ice Age began to recede in North America. People of Asian origin and mammals like the wooly mammoth made the trek more than fifteen thousand years ago.

Archaeologists digging in Colorado have found spear points among sets of bones belonging to woolly mammoths, dating about eleven thousand years ago. Although the woolly mammoth became extinct some seven thousand years ago, it is evident that the large mammal was hunted by some of the first humans to inhabit the mountain ranges.

The American bison also migrated across the strait some ten thousand years ago and became the major source of subsistence for the prehistoric humans after the woolly mammoth disappeared. Signs of these early humans have been found in various archaeological sites throughout Colorado.

Evidence of prehistoric Indians has been found in southwestern Colorado in the Mesa Verde area, and their cliff-dwelling homes have been explored for clues of their existence. About the time the Christian era began on the other side of the globe, the Anasazi ("Ancient Ones") grew crops and hunted small animals. The first ones have been labeled "basket-makers." Later, they developed pit-houses and pottery making. Still later, these human occupants, who didn't have a written language, began building and living in community-oriented structures. Then, for a reason not yet discovered, they moved to the south, abandoning the shelter of their caves recessed on mountain ledges. No sign of the ancient ones has been found in Colorado after 1300 AD.

The Ute Indians began to appear in about 1000–1200 AD. Studies of their language and lifestyles indicate that they originated in Mexico and moved northward to populate the plains and mountains, including Colorado. Other Indian tribes, like the Arapahoe, Apache and Comanche, were at home on the Eastern plains; the Navaho built their pueblos on land located to the south. But the Utes mastered life in the Rocky Mountains, adapting to a nomadic existence in which they followed and hunted the bison, depending on that shaggy beast for food and shelter and most of their needs.

The legend that Utes have passed forward as the story of their origin tells of the Creator, who collected sticks representing various peoples of the time and put them all in a bag. The coyote, who is portrayed as a trickster and troublemaker, came upon the bag and opened it up, releasing most of the people, who spread in many directions, all speaking different languages. The few sticks left in the bag represented the Utes, who would thereafter be very brave and able to defeat the rest.

Many of the sites that have been discovered in South Park are indicative of Utes campsites. These were set up primarily for signal stations or lookouts. Remains of tepee rings and food preparation devices (*metates* and *manos* for grinding grain, berries and dried meat) have been found on such sites. Many arrowheads have also been found.

The early Utes lived in *wickiups*—domed willow huts fifteen feet in diameter and eight feet high and covered with willows, bark and grass or any available material that would keep out the weather. Leather-covered tepees were not used until the horse was obtained. The opening of the wickiup always faced east so that the occupants would see and rise with the sun at dawn.

When the season changed, belongings were packed onto a travois and dragged by harnessed dogs to the next location. The Utes came to South Park during the summer season to take advantage of the warm mineral springs, salt marshes and the bison that ranged there. But winter found them at lower elevations and warmer locations.

Bison were hunted by driving them off the edge of a cliff or into deep snowdrifts. The hide was removed and the meat carefully cut up and prepared for storage. The brain of the animal was used for tanning the hide, which was used for clothing and shelter.

The Utes used roots and berries for food, as well as insects and smaller animals that were hunted. Rabbit furs sewn together made a warm blanket.

When members of the tribe died, the body was wrapped in buckskin and buried in a cave entrance or a rock crevice. The Utes did not normally burn their dead or elevate them into trees or on scaffolds as other Indian tribes did.

While there were, no doubt, Ute Indians in the area that we now know as Fairplay, they were not permanent residents but frequent migrant visitors.

THE SPANISH

The future of the United States and, in particular, Colorado, was largely influenced by three European countries that were alternately allies and enemies of one another. England, France and Spain all vied for power during the seventeenth and eighteenth centuries, and the New World became something of a pawn among them as they each tried to own and occupy parts of the North American continent.

Spain was one of the first countries to become interested in exploring the New World to look for the riches that were thought to be there and was dominant through the sixteenth century. Spanish adventurers were encouraged by a legend that began in about 1150 AD around the time of the Moorish conquest of Spain. The story was that seven bishops from the city of Merida carried with them Christian objects as they escaped their Muslim conquerors. They took their precious artifacts to the New World and founded the Seven Cities of Cibola, each of which were supposed to be rich with gold and jewels.

After Christopher Columbus began his famous voyages in 1492 and found a totally new continent to conquer and explore in the name of Spain, the Spanish were encouraged to pursue further conquests.

Hernando Cortez, born in Medellin to a family of lesser nobility, was described in his youth as restless, haughty and mischievous. He studied law and Latin, and his parents envisioned a profitable legal career for him. But he became frustrated with his life in a small provincial town and planned to sail to the New World, excited by tales of discovery and conquest, gold

and Indians in strange unknown lands. At first, he was delayed by an injury suffered while he hurriedly escaped from the bedroom of a married woman, but he finally left for Hispaniola in 1504.

After spending several years in Hispaniola and Cuba, Cortez had become influential as the mayor of the capital of Cuba. Ever more ambitious, he took eleven ships, five hundred men, thirteen horses and a small number of cannons to the Yucatan Peninsula in Mayan territory, all unauthorized by the Cuban governor. After several years of fighting both the Aztecs and his own countrymen, Cortez claimed the Aztec Empire for Spain in 1521, renaming the capital city Mexico City. He became governor of "New Spain of the Ocean Sea." During his tenure as governor, Cortez managed to destroy Aztec temples and build Mexico City on the remains. He also supported efforts to evangelize the native people to Christianity and encouraged development of mines and farmlands, sending much wealth of gold and silver back to Spain. He was one of the first to import African slaves to the New World.

Having been accused of numerous abuses of his power, Cortez returned to Spain in 1528 to defend his actions. He went back to Mexico a final time in 1547 and died that year of pleurisy at the age of sixty-two, a wealthy but embittered man. He left, however, a number of illegitimate children, to whom he had convinced the pope to give legal status.

Meanwhile, another Spaniard, Francisco Vasquez Coronado, had migrated in 1535 from his home in Spain to Mexico. Coronado married into an influential family and subsequently became governor of New Galicia, a province northwest of Mexico. He sent Friar Marcos and a companion, Stephen, north to New Mexico to investigate newly surfacing rumors of the riches of the Seven Cities of Cibola. Although Stephen was killed by the Zuni Indians, Marcos insisted that he had stood at the top of the hill and viewed Cibola, the city of gold.

Excited, Coronado pawned most of his wife's estates for money to command an expedition to find the legendary gold. In 1540, the expedition set out, complete with 335 Spaniards, 1,300 natives, 4 Franciscan monks and several slaves. The entourage traveled north to the village indicated by Marcos in what is now southern Arizona and met with a crushing disappointment. The Zuni Indians were a poor folk, barely managing to exist. There was no gold, only a few turquoise stones. After sending several scouting parties out in different directions, the main body found the Grand Canyon and the Colorado River. As they traveled, Coronado confiscated food and supplies from many of the Indian villages, killing the natives when they protested the theft of their meager possessions.

Heading northeast, the expedition discovered herds of buffalo, which they slaughtered for food. They came across an Indian that they named the "Turk," from whom they learned about a wealthy civilization called "Quivera," which, he assured them, was far to the east. It is thought that the Turk may have been engaged in persuading the expedition to leave the native settlements by leading them toward a fictitious location. Coronado's group finally came upon a large river that we now know as the Arkansas. They had gotten as far as what is now southeast Kansas. The natives there lived in straw-thatched huts and survived on their meager crops of corn, beans and squash. There was no evidence of gold or the riches of the mythical Cibola. Again disappointed, Coronado decided to give up the quest, but not before he had the Turk garroted for his deception.

Although the expedition returned home in failure after two years, the information recorded describing the land to the north turned out to be invaluable. And the Spanish had come even closer to Colorado.

Meanwhile, England was becoming a threat to the Spanish and its territories. In 1579, Sir Francis Drake had sailed around the edge of South America and up the Pacific coast, landing at a location in what is now California. Spain decided that it must colonize its possessions in the New World to retain its power there. To add insult to injury, England soundly defeated the famous Spanish Armada in 1588.

Juan Oñate, the son of a wealthy silver mine owner in Mexico, married a woman who was a granddaughter of Cortez and great-granddaughter of the Aztec emperor Montezuma. Oñate was ordered by King Philip II to colonize the northern frontier of New Spain, and he began his expedition in 1598 by fording the Rio Grande near the present site of El Paso, Texas. He founded the province of Santa Fe and became that province's first governor.

Resistance quickly developed when Oñate demanded large amounts of supplies from the Acoma tribe to support his troops. As the supplies were essential for the Acoma Indians' own survival, they resisted and killed thirteen Spaniards in the fray. Oñate retaliated by killing eight hundred villagers and enslaving the remaining five hundred women and children. To deter further resistance, he then decreed that the left foot of every Acoma man over twenty-five years old was to be amputated. This sentence was carried out on eighty men.

After several expeditions in which Oñate was looking for a usable ocean port instead of the laborious overland route across New Spain, he was recalled to Mexico City in 1606 to answer charges of cruelty to Indians and colonists. He was convicted of the charges, but an appeal resulted

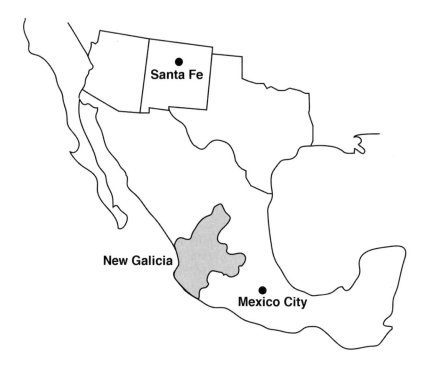

Map of Spanish explorer origins. *Drawing by author.*

in his being cleared. He was, however, banished from New Mexico and eventually went to Spain, where he became head of the mining inspectors for the entire country.

Although the Spanish exploited Indian tribes in New Mexico, the Pueblo in particular, the first record of an encounter with the Ute Indians was in 1637 in the San Luis Valley of Colorado. The Spaniards had come to hunt bison and to look for silver and gold. As a result of the battle, eighty Ute prisoners were taken to Santa Fe and forced to work in a textile workshop. In 1640, some of the Utes escaped, taking horses with them. This began a new era for the Utes, as they now had transportation enabling them to move quickly and hunt more efficiently. By 1675, all of the Ute tribes had obtained horses.

During the seventeenth century, the Spanish tried to colonize their holdings in Mexico and the southwest of what was to become the United States. They alternately traded with and fought the Indian populations and pushed their claims ever further to the north as they chased down slaves that tried to escape and punished the Indians who dared to oppose their rule.

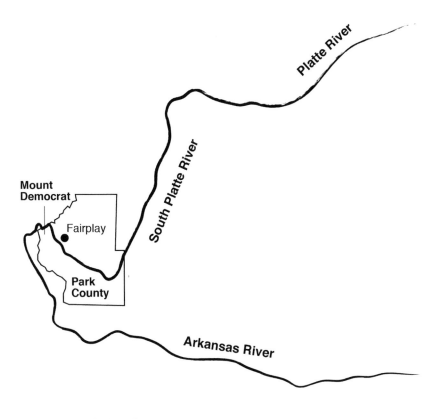

Major rivers. *Drawing by author.*

By this time, the French were expanding, too. They had developed a presence in the northeast and the Great Lakes area while looking for waterways suitable for shipping the furs that their trappers had brought from the western mountains. In 1682, Robert Cavelier, Sieur de LaSalle, and his crew began at the southern tip of Lake Michigan and launched well-laden canoes into the icy waters of the Mississippi River. When they reached the delta of the Mississippi, LaSalle proclaimed the vast drainage basin of that great river for France.

The Arkansas River and the Platte River, two major tributaries that eventually flow into the Mississippi River, as well as the Rio Grande that empties into the Gulf of Mexico, originate in Colorado, where the Spanish had been trying to establish their presence. The origins of the East Arkansas and South Platte Rivers are in close proximity, one on either side of Mount Democrat, which is one of the mountain peaks that hover over Fairplay. The Rio Grande has its beginning in southwest Colorado.

Juan de Ulibarri was one of the first Spanish explorers to enter Colorado. Ulibarri was looking for hostile Indians in 1706 and found them at El Quartelejo (near Las Animas, Colorado, on the Arkansas River). He was disturbed to find that the Indians had French rifles, thus confirming his suspicion that the French were trying to expand in what he considered to be Spanish territory. Ulibarri officially claimed the eastern plains of Colorado in the name of Spain.

England and France were both trying to get a foothold in America. The French had come from Canada and the Great Lakes, and the English had established colonies along the east coast. King Louis XV of France convinced Charles III of Spain to join them in the French and Indian War against England that came to hostilities in 1759. France offered Spain the Louisiana Territory in exchange for a large loan and entry into the war against England. England promptly declared war against Spain and decimated a Spanish fleet in the West Indies. Then, in 1763, having lost the war with England, King Louis XV ceded to Spain all of the Louisiana country west of the Mississippi. King Louis decided he would rather give the territory to his ally, Spain, than to a more formidable enemy, England.

Spain and France both aided the American colonies in defeating their common enemy, King George III of England. None of the European countries expected the backwoodsmen colonists to object to taxation without representation so adamantly. After momentous events in America in 1776, France endured its own painful revolution, overthrowing an oppressive monarchy. From that turmoil emerged a military figure who made the French and the Western world sit up and take notice. Napoleon Bonaparte envisioned a re-creation of the Roman Empire, with himself as its emperor and Paris as his capital. Bonaparte broke the promise made to Spain in 1763 and in 1800 took back the Louisiana Territory in America by the Preliminary and Secret Treaty between the French Republic and His Catholic Majesty the King of Spain. Spain was not in a position to object, weakened by its own rulers' excesses, and somewhat reluctantly accepted a province in Tuscany in exchange for the vast territory that had been only minimally explored and settled.

Spain still claimed Florida and the port of New Orleans. President Thomas Jefferson became somewhat annoyed when the Spanish began to impose new shipping regulations at that port. And he became alarmed when the French army landed forces in Santo Domingo—way too close for comfort. Jefferson sternly declared that the fledgling nation of United States would align itself with England if France took control of the port of New

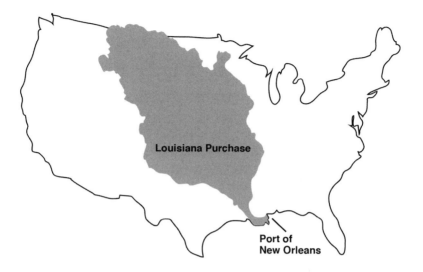

Louisiana purchase. *Drawing by author.*

Orleans. He then sent a delegation to Paris to try to buy the port for a sum of $2 million. The delegation was taken by complete surprise when Napoleon offered to them the entire Louisiana Territory, including the port of New Orleans, for $15 million. They quickly but unofficially accepted the offer and hoped that the American Congress would approve the expenditure. The transaction at once doubled the geographic size of the United States.

The somewhat loosely recognized boundaries of the new acquisition took in much of the eastern plains of Colorado. It wasn't until 1819 that the border between Spanish Territory and the United States was more definitely agreed upon as the Arkansas River north to its source, thereafter north to the forty-second parallel. The Arkansas River originates near Mount Democrat and the Continental Divide and flows southerly through what is now Salida, then easterly through Canon City and Pueblo. The river eventually empties into the Mississippi River after flowing through the states of Kansas, Oklahoma and Arkansas.

The part of Colorado that included South Park and the area that was to become the town of Fairplay was now a part of the United States of America.

TRAPPERS AND EXPLORERS

O rders issued to Captain Zebulon Montgomery Pike in 1806 were threefold: 1) escort fifty-one Osage Indians back to their homes in eastern Kansas, 2) negotiate a peace between Kansas and Osage tribes and attempt to make contact with the Comanches on the high plains and 3) explore the headwaters of the Arkansas River, then proceed south, locate the source of the Red River and descend it to the Mississippi River.

Captain Pike left Fort Bellefontaine near St. Louis and quickly dropped off the Osage Indians. From there, he made for southern Nebraska, where he announced to the Pawnees at their village on the Republican River that they were to remove the Spanish flag and fly the Stars and Stripes instead. The expeditionary force then headed south to the Arkansas River, where the group split. Half the men went downstream until the river emptied into the Mississippi, from which point they returned to St. Louis. The remaining men, including Pike, went west on the Arkansas, headed for the source.

After crossing Colorado's eastern plains, Pike and his men came to the "Grand Peak," which was later to be given his name. An abortive attempt was made to climb it, but the men were ill equipped to handle the winter weather that was now upon them and did not finish the climb. The men headed north into South Park, crossed what is now Trout Creek Pass and then headed down the mountainside, finding a river in the vicinity of Twin Lakes, which we now know is part of the Arkansas River system.

Pike led his men, hungry, cold and exhausted, south over the mountains. They came upon the Rio Grande at a point near what is now Alamosa.

There they built a rudimentary fort. Pike claimed to have thought that the river nearby was the Red River that he had been instructed to locate. It wasn't long before Spanish troops found their encampment, took them into custody and marched them southward to Santa Fe, where Pike was detained and the materials he had been recording confiscated. After a year in prison, Pike was escorted across Texas and released at the Louisiana border.

The boundary between Spanish Territory and American Territory had been established (albeit loosely defined) as the Arkansas River. It doesn't seem likely that Pike was unaware that he was in Spanish Territory if he really thought he had found the Red River, which is much farther south. His real mission may have been other than his written orders indicated.

Whatever his purpose was, Captain Pike brought back invaluable information about the geography in the unexplored West and logistics of the Spanish stronghold. While he was in Santa Fe, he became acquainted with James Purcell, who had similarly been incarcerated by the Spanish for trespassing in their territory. Purcell told Pike about gold that he had found while he was exploring "on the head of the La Platte," which, while a vague description, put his discovery at least in the vicinity of the future town of Fairplay.

After centuries of repression by wealthy Spanish, Mexican revolutionaries inevitably decided they deserved better treatment. In 1810, Father Hidalgo, a Mexican priest, incited a rebel army to take up arms against the Spanish. A bitter war was fought for ten years, during which the heavily armed Spanish cruelly punished any rebels who dared to take up arms against the Spanish crown. Father Hidalgo was killed, his body mutilated and his head displayed in a cage to discourage any further rebellion. New insurgents rose up to take his place, and many were similarly executed.

In 1820, Colonel Agustin de Iturbide was sent by Spain to complete what was supposed to have been a final assault on the Mexican rebels. Instead, Iturbide switched allegiances and met with the rebel leader to discuss terms. Iturbide negotiated a treaty with Spain for Mexican independence in 1821. In the treaty, Iturbide included a clause that allowed a Mexican congress to appoint a monarch of their choosing, should no "suitable member of European royalty be found to accept the Mexican crown." Iturbide himself was thus declared to be the emperor of Mexico. The new Mexican monarchy soon let it be known that they would welcome trade with their northern neighbors, a radical policy change from the Spanish enforcers.

While Mexico was suffering the pangs of revolution, explorers and trappers were busily investigating the western wilds of the American Territory. In the

1820s, beaver top hats had become extremely popular in European fashion circles, and beaver pelts brought as much as six to eight dollars apiece. Beaver were especially prolific in the streams of South Park, so trappers, who for the price of a few traps and a horse, could spend a season in the mountains and bring back pelts that netted them a sizable amount of money.

By the late 1830s, however, fashions changed, and new silk top hats took the place of those made with beaver pelts. Trapping beaver in the mountain streams was no longer profitable.

The 1803 Lewis and Clark expedition had opened up exploration of the country's northwest and sparked would-be settlers to cross the Rocky Mountains on what became the Oregon Trail. Thomas J. Farnham, a lawyer practicing in Illinois, was hired by easterners to take a group of nineteen people to Oregon and record what he found along the way. They set out in 1839, their route taking them from Missouri, following the Arkansas River over the Continental Divide to its source, then northwest. In his *Travels in the Great Western* Prairies, Farnham describes the "height of land between the waters of the Platte and those of Grand River" (Colorado River, which originates northwest of what is now Leadville and flows toward the Gulf of California and the Pacific Ocean). He proclaims, "From this eminence, we had a fine view of Bayou Salado."

Farnham then tells of the misfortune of one of their packhorses that became ill and finally died, the victim of "poisonous wild parsnips." Current knowledge might suggest that the horse had eaten locoweed, still a killer of horses and wild game in South Park. Farnham also wrote much of the "Utaw Indians" and of their continuing migration from one side of the mountains to the other. He noted that they spoke the Spanish language and that some of them had embraced the Catholic faith.

Rufus B. Sage was a journalist and political activist in Ohio when he became interested in exploring the region beyond the Missouri frontier. In 1842, Sage organized a party to explore the West. He spent three years in Colorado, recording information about the mountains, streams and valleys and the inhabitants and traders.

Sage described his route on one excursion up the Blue River, across Hoosier Pass, down Fairplay Creek and into South Park. He told of camping in a beautiful grove of aspen and observing huge herds of buffalo. He also related a problem with magpies, large local birds that are noted scavengers. The pack animals, hardy burros, had been burdened with huge loads of supplies, which caused their backs to become sore. The magpies relentlessly attacked the backs of burros. Sage's men covered the animals with buffalo

Burro. *Photo by author.*

robes to try to keep the magpies off, and "even then the rapacious cormorants could scarcely be prevented from renewing their cruel repast." Sage wrote and published *Scenes in the Rocky Mountains* after he returned to Ohio.

John Charles Fremont was a second lieutenant in the United States Corps of Topographical Engineers and had married the daughter of powerful U.S. senator Thomas Hart Benton. Senator Benton was interested in exploring the Oregon Territory, so he managed to send his son-in-law on four different expeditionary tours to the West and back. In 1843, starting the second expedition, Fremont was only incidentally in South Park, when he took a detour that brought him over Hoosier Pass, following the Middle Fork of the South Platte, to meet up with Kit Carson in Pueblo. Carson, a well-known mountain man, was hired to be the guide, as the entourage headed over the Rocky Mountains, finding a route to California and returning to the nation's capital to report conditions in the West.

As Fremont's men set up camp in a mountain meadow next to the Middle Fork of the South Platte River, they encountered a large party of Indians. The men proceeded to prepare a defensive position until they discovered

that the Indians were Ute women and children who "filled the air with cries and lamentations, which made us understand that some of their chiefs had been killed." The women asked Fremont to join the Utes in fighting their Arapahoe enemies. Fremont wisely decided that it would not be a good idea to take sides in the conflict and rapidly proceeded past the battle scene.

Fremont's presence in the area is now marked by a monument at the top of Hoosier Pass.

George Ruxton was an Englishman who left school to join the British military at a very young age. He went to Spain and fought on behalf of the Spanish crown when civil war was raging there. Ever an adventurer, Ruxton left the army and traveled to Mexico in 1846. The Mexican War with the United States was in progress, but Ruxton toured southeastern Colorado with only the company of a servant guide, his horse and pack burros.

Ruxton hunted and camped near the headwaters of Fountain Creek, often going into Bayou Salado after game. He described a number of near-catastrophes during which he often checked his topknot to see if it was still there when he knew Indians were nearby. On one occasion, after a long day of hunting, he lay down on a rock warmed by the sun and fell asleep. Waking up to the smell of smoke, he found that the whole side of the mountain was on fire. He gathered his horse and burros and coaxed them across the creek to relative safety from the flames. Ruxton had camped too close to a band of Arapahoes, who had set the fire in hopes of trapping him and stealing his animals and gear.

A number of Ruxton's descriptions involve his experiences in cold, snow and wind: "Beneath the mountain on which I stood was a narrow valley. A hurricane of wind was blowing at the time. On the mountain-top, it roared and raved through the pines, filling the air with snow and broken branches and piling it in huge drifts against the trees."

When Ruxton returned to England in 1847, he wrote *Wild Life in the Rocky Mountains*. In spite of having left school at an early age, he had become a talented writer, as he aptly described his experiences in the American West.

Chapter 5
TERRITORIES

While Mexico was gaining independence from the Spanish, the United States was embroiled in a state-by-state battle over the slavery issue. The slave trade had been abolished by Congress in 1808, but southern states depended on their slaves for their economic existence. Northern states strongly opposed slavery, and there were numerous heated discussions about which states would be pro-slavery and which states would be "free." The issue came to a head when Missouri applied for statehood as a "slave" state. This would upset the balance, as there were now twenty-two states, eleven allowing slavery and eleven prohibiting the practice.

The issue was temporarily settled and the balance kept intact when Congress voted to admit Maine as a "free" state in 1819 and Missouri as a "slave" state in 1820. The Missouri Compromise, passed in 1820, was a critical decision because it established the right of the federal government to determine the status of slavery in the states, at the same time providing that slavery was to be excluded from Louisiana Purchase lands north of latitude 36°30′. (Colorado latitudes are between 37° and 41°.)

Meanwhile, in the Wild West, other issues were developing. Mexico, eager to colonize the Texas territory, agreed to give a large land grant to Moses Austin, a Missouri banker. Stephen Austin, his son, brought more than three hundred families to the Texas territory, and by 1829, Americans outnumbered Mexicans there. The Mexican government instituted property taxes, tariffs on U.S. shipped goods and prohibition of slavery. American families continued to move to the Texas territory, bringing their slaves with

them. Texas territory then included the strip of land that extended north into Colorado between the sources of the Arkansas River and Rio Grande.

The younger Austin called Texans to arms and declared independence from Mexico in 1836. General Santa Anna, who had become the dictator of Mexico, ignored the advice of Britain, France and the United States and took an army of three thousand men to San Antonio, where he killed all two hundred of the defenders at the Alamo. Santa Anna won another battle at Goliad before Sam Houston's troops caught up with the Mexican army and sent them fleeing back across the Rio Grande. As the Mexican army scattered in confusion, a number of them were captured, among them General Santa Anna himself.

Texas, rejoicing in its victory, elected its own government, with Sam Houston as president, although most of its citizens wanted annexation to the United States immediately. In the United States, legislators still argued with one another over slavery and still did not want to change the balance of slave states to free states by admitting yet another slave state. Mexico sullenly retreated its troops but did not admit that Texas was no longer a Mexican territory.

U.S. president James Polk ardently believed in the newly coined phrase "Manifest Destiny," under which many politicians felt that it was a foreordained conclusion that the United States would extend from the Atlantic to the Pacific Oceans. In 1845, Congress declared Texas to be the twenty-eighth state in the union. The action infuriated Mexico, who immediately severed diplomatic ties with the United States.

President Polk sent an emissary to Mexico to offer $25 million for the Texas territory, as well as Spanish territories west to the Pacific coast. Mexico, in the midst of yet another internal conflict, refused to receive the emissary. Inevitable shots were exchanged, giving Polk the excuse to get Congress to declare war in 1846. American troops were amassed and sent to Mexico in three major offensives: one from the California and Pacific coast, a second from New Mexico and a third from the eastern coast of Mexico that finally occupied Mexico City.

Defeated not by overwhelming numbers but by superior weapons technology, the Mexican government agreed to the land accession proposed by the American government. The Treaty of Guadalupe Hidalgo was signed in February 1848. A payment to Mexico of $15 million and forgiveness of a $3 million debt owed to U.S. citizens were part of the settlement terms. The United States gained territory that ultimately comprised the states of California; Nevada; New Mexico; most of Arizona and Colorado; and parts of Texas, Oklahoma, Kansas and Wyoming.

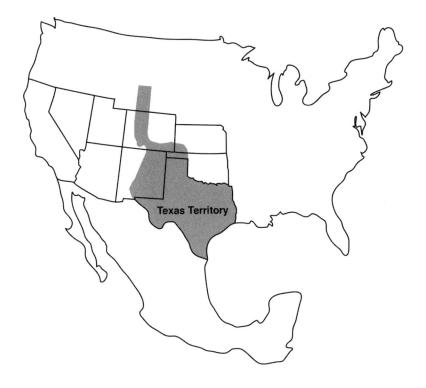

Texas Territory. *Drawing by author.*

It is perhaps noteworthy that, early in the conflict, New England philosopher Ralph Waldo Emerson was quoted as saying, "The United States will conquer Mexico, but it will be as the man swallows arsenic, which brings him down in turn. Mexico will poison us."

The Kansas-Nebraska Act of 1854 further fueled the battle between slave and free states. The purpose of the act was to facilitate creation of a transcontinental railroad, but its passage was hotly contested because of the "popular sovereignty" issue. The act established that settlers could vote to decide whether to allow slavery or not and repealed the Missouri Compromise Act of 1820. The bill was hotly debated in the Senate but finally passed. In the House, the bill was not only hotly debated, but one well-armed, pro-slavery southerner came prepared to use more than words and was arrested by the sergeant-at-arms before he could do any serious damage. In spite of the histrionics, the bill was passed.

Thus the Kansas and Nebraska Territories were created. Kansas Territory was located between the thirty-seventh and fortieth parallels, and Nebraska

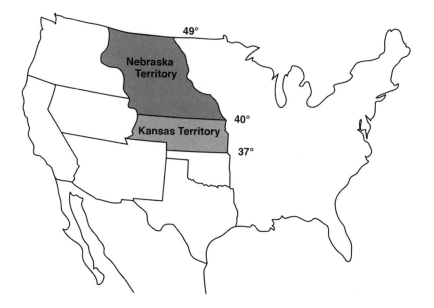

Nebraska-Kansas Territories. *Drawing by author.*

Territory was between the fortieth and forty-ninth parallels. The fortieth parallel lies just north of Denver, so the future Fairplay was now part of Kansas Territory.

But not for long.

Chapter 6
FIRST MINERS

O n a visit to Denver in 1859, noted journalist A.D. Richardson wrote:

> *Making governments and building towns are the natural employments of the migratory Yankee. He takes them as instinctively as a young duck to water. Congregate a hundred Americans anywhere beyond the settlements, and they immediately lay out a city, frame a state constitution and apply for admission into the Union, while twenty-five of them become candidates for the United States Senate.*

The result of the 1854 Kansas-Nebraska Act was that the future state of Colorado was now parts of four separate territories: Utah, New Mexico, Kansas and Nebraska. But since no treaties existed with the Indians, all the land was still technically theirs.

In 1855, the Kansas Territory legislature created Arapahoe County, comprising the entire western portion of the territory from a line on the east extended north from the northeast corner of New Mexico to Nebraska Territory, and on the west to Utah Territory along the Continental Divide. There being few occupants in the newly created Arapahoe County, the act of the Kansas Territory legislature went pretty much unnoticed until the discovery of gold in 1858. When gold seekers began to populate the area, those trying to establish legal authority held an election in Denver in March 1859 for officers of Arapahoe County. Embroiled in affairs just prior to the Civil War, neither Kansas Territory nor the U.S. Congress reacted.

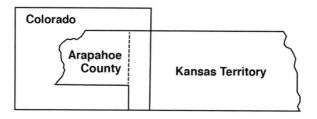

Arapahoe County. *Drawing by author.*

Largely ignored, settlers decided that they needed their own government and met in April 1859 to draft a constitution for the State of Jefferson. Not wanting to incur the burden of taxation that a state would require, voters rejected the proposal at the referendum held in September. They did, however, approve a constitution for the Territory of Jefferson on October 24, 1859, which expanded to include more of Nebraska and Utah Territories. Officers were duly elected, and the new territorial legislature organized twelve counties, one of which was the current Park County.

When the proposal to create Jefferson Territory came before the U.S. Congress, very little interest was shown, and congress adjourned without approving the bill to establish Jefferson Territory.

While all of this was happening on a national and territorial level, miners had recognized the need for local law enforcement. The *Fairplay Diggings Book of Revised Laws* was penned on April 26, 1860. Book A began as follows:

> *Sec. 1: Be it enacted by the miners of Fairplay District that all bank claims shall be in size 75 feet front and 300 back.*
>
> *Sec. 2: That this district shall extend 2 miles up and down the stream and 1 mile on either side.*
>
> *Sec. 3: Be it enacted bye* [sic] *the miners of Fair Play Diggings that all cases to be settled by arbitration of 3 miners that they shal* [sic] *be allowed for compensation the sum of $5 each in each case.*
>
> *Sec. 4: That in case of appeale* [sic] *from the arbitrators to a miners meeting the losing party shal* [sic] *pay to the miners assosition* [sic] *the sum of $25 to be applied to and for Beniv* [Benevolent] *Purposes.*

Claims were then recorded, numbered by their proximity above or below the discovery or meridian line. As claims were abandoned, new miners took

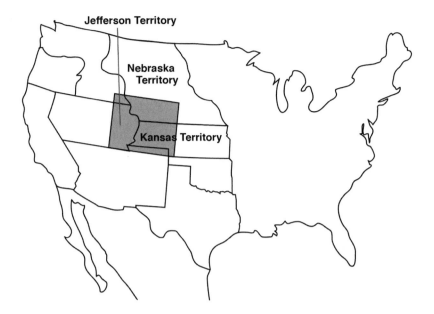

Jefferson Territory. *Drawing by author.*

them over. The first appointed recorder, H. Henson, made all the appropriate entries in the official book of mining claims.

On a regional level, miners' courts were organized and officers elected. On September 22, 1860, the United Mining District was established, including the Arkansas, Blue River and Park Districts. The offices of president, secretary, circuit judge, marshal and recorders for each of the districts were chosen.

In November 1860, Abraham Lincoln was elected president. Shortly thereafter, the Confederate States of America began to secede from the Union, and the War Between the States was imminent.

When the State of Kansas was admitted to the union as a "free" state on January 29, 1861, its newly established border left Jefferson Territory officially unorganized. Colorado Territory was created on February 28, 1861. Boundaries of the newly created territory were pared down to the current configuration of the State of Colorado, and seventeen counties were identified, one of which was again Park County.

President Lincoln appointed William Gilpin the first territorial governor. Colorado City, now a suburb of Colorado Springs, was designated the capital of Colorado Territory. Gilpin had been one of the explorers with Fremont's expedition in 1844 and was familiar with the territory. He was a staunch

Union supporter and set about shortly after his arrival in Denver in May 1860 to make the atmosphere uncomfortable for Southern sympathizers.

The 1858 discovery of gold in the Colorado Rockies had started a major migration of people eager to find their fortunes. The California gold rush a decade earlier had only whetted the appetites of adventurers, and now there was another chance to get rich.

After the initial rush, the easily found gold had been depleted, and it became harder and harder to come by a paying claim. Miners had already begun to leave for more promising gold fields when the war broke out. Up to that point, pro-Union men worked side by side with pro-Confederate men, but now they began to take sides.

The swelling population had pushed westward from the Gregory Diggings to Tarryall and its neighbor, Hamilton, along the Tarryall Creek. Finding no welcome there, would-be miners ventured further west, and some settled on the banks of the Middle Fork of the South Platte River. Here a settlement began to emerge.

Charles P. Basyc of St. Louis, Missouri, described the early days of Fairplay in a letter to the *Fairplay Flume* in March 1910. The article heading was "Fairplay in 1859." Basyc tells of the Reynolds boys and the Reed brothers, who were the first to take claims in the Fairplay area and who occupied the first house built there, called Three Cabins. He also mentions that he left in September 1861 at the age of seventeen to join the Confederate Army, selling his half-interest in Claim No. 9 to his partner, P.A. Garrett, who was a Missourian but a Union man.

The Reynolds brothers, who had come from Texas, were also sympathetic to the Confederate cause. They got crossways of Union sympathizers and left the area with a Rebel group who headed south.

During the summer of 1861, Governor Gilpin sent Captain Richard Sopris to nearby Hamilton to recruit soldiers for the First Regiment of Colorado Volunteers. Answering the ad for "able-bodied men, ages eighteen to forty-five to serve three years or the duration of the war," forty-three patriotic young volunteers gave up their lives of prospecting for "fifteen dollars a month and plenty of grub."

Governor Gilpin had been given the authority to form the military unit, but Congress neglected to approve payment of vouchers to fund it. Suppliers became more than irate when they had furnished supplies to the Colorado Volunteers and their promised payments became more and more in arrears.

Hearing that the Confederate general Henry Sibley had amassed forces in Texas and had defeated Union forces in New Mexico on the way to

Colorado, his object to capture sources of gold to finance the Confederate cause, Governor Gilpin dispatched his Colorado Volunteers south to protect the territory.

Colonel John Slough was in command, and he force-marched his troops from Denver more than four hundred miles in fourteen days to get to the point to which Confederate forces had advanced. Glorieta Pass is located in the Sangre de Cristo Mountains in what is now New Mexico.

On March 26, 1862, the battle began. Captain Slough split up the Union detachment, sending a party led by Major John Chivington to the rear to flank the Rebels. The Confederate forces were numerically superior and were close to pushing the Union soldiers back over Raton Pass into Colorado Territory. However, due to a lucky observation, Major Chivington's party had come upon the Confederate supply station and managed to destroy their weapons, ammunition, horses, mules and other necessary supplies. The Confederates called for a truce and had to withdraw back to Texas.

The Battle of Glorieta Pass has been hailed as the "Gettysburg of the West," and there was no further serious threat to the Colorado Territory from the Confederacy for the duration of the war.

A TOWN EMERGES

In his letter to the *Fairplay Flume* titled "Fairplay in 1859," Charles Basyc wrote that the first store was a tent on the south side of the Platte, owned by a man named Johnson. Kate, the daughter of Johnson, was the first white woman in that section, according to Basyc. He also mentions Hugh Murdock, one of the earliest settlers in Fairplay, who was first involved in mining and later owned and operated a hotel and then a store. Basyc's statement about his own claim—a half-interest in No. 9 below Discovery—is born out in the Fairplay Mining Claims record, Book A.

A family history reveals that David F. Miller came to South Park in June 1860 by oxcart. Miller's wife, Elizabeth, operated a boardinghouse in Fairplay that later became a large hotel. Miller homesteaded the nearby land that became the Buyer-Coil Ranch.

The *Rocky Mountain News* advertised in September 1860 that Hinckley & Co.'s Express, the Western Stage Company line, "goes through Fairplay." Some of the locals tried to change the name of the town to Platte City in 1861, but the name Fairplay remained.

It was in 1861 that the legend of Silverheels was born. Supposedly a dance-hall girl from neighboring Buckskin Joe was nicknamed "Silverheels" because of the silver shoes that she preferred to wear. When a smallpox epidemic hit the mining camp, most of the women and children went to Denver to escape the threat. Silverheels remained and was credited with nursing a number of the miners back to health. She did not escape contracting the dreaded disease, however, and although she managed to

survive, the pox left her with disfiguring scars. Grateful miners took up collections to show their appreciation for her care, raising several thousand dollars. When they attempted to give the money to her, she had mysteriously disappeared. But they came upon another idea to honor her and named the mountain that overlooks the town from the north Mount Silverheels. Many have undertaken research to find the actual identity of the real "Silverheels," but none has been successful. So the story remains a legend.

Mount Lincoln, at 14,286 feet, is the tallest of the mountains that tower over the town of Fairplay. The origin of the name began in June 1861, when Wilbur F. Stone, then a placer miner, ascended the mountain to its peak and marveled at the scenic beauty from that vantage point. Stone descended to the town of Montgomery, at the base of the mountain, where he called together a meeting of the citizens to discuss an appropriate name for the magnificent peak. They selected the name of the president who had just been elected. Stone later became a prominent historian of Colorado, and when a nation newly emerging from a devastating internal war was also forced to face the assassination of its president, he wrote a moving article about the naming of the mountain, which was widely published.

In August 1861, the *Daily Colorado Republican* and *Rocky Mountain Herald* published a report from a Buckskin Joe resident:

> *The recent heavy rains here have done much damage. At Fairplay, the large ditch broke its banks and went tearing down the banks, carrying with it several houses with all their contents. The inmates had scarcely time to get out of the houses, leaving everything they possessed. The damage is very great and cannot be easily repaired. It will fall very heavily on the miners.*

A year later, the Colorado Territory legislature voted to incorporate the Fairplay Ditch and Fluming Company. The Fairplay Ditch was built to aid the miners in hydraulic mining operations. One of the necessary components for getting gold out of the ground was a constant source of running water, and the ditch served this need, as well as the domestic needs of the growing town.

Daniel Ellis Conner wrote that he visited Fairplay early in 1862 with four companions. Conner described a "large rude house built of logs" that was fitted up as a "deadfall," as miners referred to a saloon, run by a bow-legged gentleman whose only known name appeared to have been "Ole Mack." Conner witnessed a traveler attempting to get a room in the adjoining hotel. Upon asking the price of the room, the traveler was quizzed about

any blankets and deer meat he had brought with him to contribute. Having neither, the traveler was handed a playing card, the trey of clubs. The puzzled traveler was finally enlightened and told that the matching card, the trey of spades, was attached to the door of his room. The room was sparsely furnished with a bunk consisting of a crude rectangular pole frame covered with pine boughs and a few old blankets.

Conner was, no doubt, anxious to survive the night and leave the following morning, as he and his companions—all Confederates—were passing through and were not eager to draw attention to their loyalties in a staunchly Union atmosphere. Conner had kinder words for the "reindeer" he saw on the trail (most likely elk) than the hotel where he had spent the night.

On April 3, 1862, a post office for the town of Fairplay was approved. The post office was to be located on the north bank of the Platte River, and Fairplay was described as a "village and mining settlement with from 200 to 600 inhabitants."

In June 1862, the *Rocky Mountain News* reported that Gus Newman, formerly connected with a New York store, would be opening "a large and general store in the Fairplay mines. He is now shipping a splendid stock of groceries, provisions, miners' supplies, clothing and outfitting goods… the Fairplay folks will have a good opportunity to be supplied with almost anything they want."

On the west bank of the river, the suburb of Alma boasted a few homes and a hotel named the Winslow House. The *Rocky Mountain News* reported in October 1862 that Mr. Winslow had come to Denver to spend the winter. Winslow was quoted as saying that there had lately been a heavy exodus from the Fairplay mines. A few years later, Alma moved north about six miles to its present location near Buckskin Gulch Creek. The town already known as Fairplay began to develop on the east side of the Middle Fork of the Platte.

HOW FAIRPLAY GOT ITS NAME

The most commonly known story of how Fairplay was named came from the first miners that took their searches for gold further west when they found the claims in Cherry Creek and Gregory Diggings all taken. They reached Tarryall and found that those claims were also being worked and none of the miners there were willing to split off their closely defined pieces of ground in favor of newcomers. Disgusted, the latecomers grumbled that, instead of Tarryall, the gold field should be called "Grab-all." They ventured even further west and found hints of color in the Middle Fork of the South Platte River. In August 1859, when they began to stake out their claims and record them in their Miners' Records, they agreed that their new sites should bear the name "Fair Play," in contrast to what they had experienced at Tarryall.

Another story, not nearly as well known, was told.

Four men, having been disappointed in finding claims, stopped at the middle branch of the Platte and panned out a considerable amount of gold. One of them, Hill, was made the banker. When the provisions were used up, they tried to get the money from Hill to buy more. He refused to part with the money for any reason. The others in the group called all the local miners together to arbitrate the problem. Another early miner, Tom Payne, acted as spokesman and presented the case to the other miners. The decision was to force Hill to weigh the gold dust and give each man his fair portion.

Hill listened to the discussion and ran out of the cabin where they were talking. He then headed to his own cabin, where the other miners found him

huddled beneath his bedcovers. They dragged him out and relieved him of the gold dust and then divided it into the proper portions. Hill refused to take his share, but the others held him down and forced it into his pockets.

One of the other miners, who a few years later became a notorious stagecoach robber, quietly watched the proceedings. After all was finished, James Reynolds was heard to remark, "Thar, b'gad, if one is the devil and the other Tom Payne, they shall have far' play!" Shortly after this incident, the miners' committee got together to establish rules and name the district. They quickly settled on the name Fairplay.

Yet a third (and considerably more romantic) story was told, this one with an epic poem to mark the incident leading to the naming of the town.

In 1860, a miner named Sanford was sinking his prospect hole, digging deep in the ground, when a man with a rifle in his hands appeared at the top of the shaft and looked down. "I have found you at last," the newcomer said. Recognizing the individual towering above him, Sanford responded, "Yes, you have, but you will give me fair play, won't you?"

Arrangements were made for a duel the following morning. Neither had called for the seconds, surgeons and witnesses usually assembled at a formal duel, but the proceeding commenced bright and early anyway. The combatants shouldered their rifles and walked the customary fifty paces before turning to fire. Sanford immediately fell, mortally wounded, and was later buried at the same spot.

A miners' court listened to the story before they reached a verdict. The surviving rifleman was Pemly, who had grown up with Sanford in Texas. But it seems that Sanford had wooed Pemly's sister, ruined her and then abruptly left her. Pemly had chased his old friend through California, Australia, New Zealand and Frazier before finally finding him at Fairplay. The miners' court found that a sister's honor had been justly avenged.

The following poem and accompanying description is taken from the October 1873 issue of *Out West*:

THE LEGEND OF FAIRPLAY

[In our summary of news, we report the destruction by fire of a great part of Fairplay, the principal town of the South Park. The following legend of the origin of its name, written some months ago, when it was rumored that an attempt was to be made to re-christen it "South Park City," will be of interest at this time. The poem appeared originally in the Pueblo People.]

I dun know as they was heros, Bill,
But I tell YOU they was game,
And I can bust
That feller's crust
What wants to change the name
Of the place where them fellers fit that day
An' give each other such good "Fair play."

Maybe yer never heard the tale,
An' maybe as yer don't know
How it came
By its cu'rus name,
So I'll tell it to you and Jo—
I aint much 'count at chinnin' yer see,
But I'll tell it accordin' to my idée.

You's both of yer worked in that old gulch,
An' sweated in that same sun,
An' yer recollects
That feller "Tex"
There's none of us never knowed;
An' mighty few would have liked to try
To stand up square to that steady eye.

He wer'nt no hand at minin', Bill,
An' he never seemed much to care.
He paid his way
From day to day,
But his heart wer'nt never there,
For he seemed to be allwus a watchin' the trail
That them fellers had made as fetched the mail.

He 'peared to be kinder waitin', see?
For somethin' as never was done,
An' all the day
Nor far away
He'd keep his favorite gun,
An' he didn't keep it for none of us,
'Cause the camp boys kinder took to the cuss.

One day, I mind it were awful hot,
So the gulch weren't over full,
"Tex" he spied
A stranger ride
Up over the bluff on a mule,
An' he jumped so quick an' gathered his gun
That none of us see'd how the thing was done.

He met that stranger full an' fair,
An' he leveled his rifle true,
Thar warn't a breath
T'wixt him and death
As the stranger MUST have knew,
But he never flinched nor turned away
As he sung out a single word: "Fair-play."

"Fair play," says "Tex" "you don't deserve,
For the dirt you have done me;--
A sister's shame,
A ruined name
An' fair play don't agree.
But I'll give you a chance for your dirty life
With pistol or gun or bowie knife."

"I hain't got nothin'," the stranger said
"To shoot or stab or cut.
I left my traps
A mile perhaps,
Back yonder at that 'ere hut."
"I promised to give fair play;" says "Tex,"
"You had better go after your rifle, I 'spects."

So the stranger rode away on his mule,
An' "Tex" come back an' stood
To see 'em pace
A forty yard space
In a clearin' out in the wood,
An' he told the boys in his quiet way
How he'd 'greed to give an' take fair play.

Do you think that stranger sloped? Not he,
He cum to time all right;
He were too good grit
To git up and git
In the face of a fair square fight.
There wer'nt no parson nor doctor there,
They meant business, not pills nor prayer.

Just forty yards apart they stood,
Each forty yards from Death;
Both as cool
As a government mule,
An' both as steady as breath.
Neither 'un flickered in nary an eye
Though a moment an' one or both 'ud die.

Then one of the boys he counted "Two,"
Then came "Fire!" By G—d!
A single shot
The reply he got,
An' both men down on the sod;
The stranger bored plumb through the heart
An' "Tex's" skull leaded 'longside the part.

They dug a hole for that stranger thar,
Exactly whar he fell.
"Tex" went away
That very day,
Which way there's none can tell,
But as he went he was heard to say,
"That son of a gun has got "FAIRPLAY."

It maybe, Bill, them Eastern chaps
Would like to change that name—PERHAPS.

Ben. Bent.

ESPINOSAS
WREAK HAVOC

J ust inside the gate of an old forgotten and abandoned cemetery up the
hill from Main and Second Streets is a marker that reads:

Abram Nelson Shoup
Born at Slate Lick, Pennsylvania
May 5, 1834
Died May 11, 1863

The Fairplay Ranger Station Cemetery contains only two other markers,
dated 1868 and 1872, but there are a total of seven actual graves there.
Shoup and four other men, whose remains were left unmarked, were victims
of a terrible blood bath that took the lives of thirty-two men before the
killers were finally brought down and the reign of terror ended.

The story of this episode in Fairplay's early history actually began in a
small village in southern Colorado called San Rafael, along the Conejos
River, not far from present-day Antonito. The Espinosa family was typical of
Mexicans who had migrated north from New Mexico but were able to only
barely eke out a living. Felipe Niero Espinosa had built a small home made of
mud-chinked poles and a thatched roof to house his wife, children and their
extended families. Unable to make much of a living, Felipe talked his brother
Jose Vivian into joining him in stealing horses and robbing freight wagons.

Early in 1863, the Espinosa brothers robbed a wagon loaded with supplies
to be delivered to a local priest. The driver of the wagon recognized the

Old Fairplay cemetery by front gate. *Photo by author.*

brothers and reported the theft to the authorities. Orders were issued to the commanding officer of Fort Garland to apprehend the thieves and confiscate the stolen goods. With the help of their families, Felipe and Vivian escaped their home, but not before they had shot and killed a Mexican corporal who was one of the troops sent to make the arrest. The soldiers, led by their Anglo officers, found the stolen merchandise and removed it all, in addition to just about everything else in the Espinosa home.

The family, already poor, was now destitute. Early in March 1863, Felipe and Vivian, realizing that they were wanted fugitives, got on their horses and headed north, swearing vengeance on the Anglos that had done this to them. About a week later, the brothers had gotten as far as Hardscrabble Creek, just south of Canon City. They discovered a man working by himself, building a sawmill. Franklin Bruce was shot through the heart, and then a cross was carved on his chest. His horse was left grazing near his body as the brothers continued on their trek.

The brothers crossed the Arkansas River and traveled north until they found a group of three men building a sawmill and a small cabin. Two of the men left, and Henry Harkins was easy prey for the Espinosa brothers, as they shot him in the head, brutally split his head with an axe and then slashed his chest repeatedly with their knives. They ransacked and dumped out everything in the cabin before leaving Harkins dead.

Felipe and Vivian found a campsite near Fourmile Creek, north of Canon City, and decided to let things die down a bit before they continued their quest to punish white men. They then traveled still farther north to Kenosha Pass and settled down to wait near a roadhouse known as the Kenosha House, located along the road between Fairplay and Denver. It wasn't long before two unsuspecting men set up camp in a nearby gulch. During the night, the Espinosa brothers began their attack. A man by the name of Binkley was killed with a single shot to the chest. The other, Abram Shoup, was stabbed numerous times and tried to run away but soon collapsed and died from his wounds.

The killers headed back toward their Fourmile Creek campsite, crossing over Wilkerson Pass and heading southeast. On the way, they discovered an isolated ranch house not far from what is now Lake George, occupied by John Addleman, who was alone and in bed. They forced him out of his bed and made him walk around barefoot before they brutally killed him.

They spent about two weeks at their campsite on Fourmile Creek before returning to their murdering trek. They again went north, crossed the South Platte River and headed toward Fairplay. Near a place called Cottage Grove, about three miles northwest of Fairplay, they fatally shot a man named Bill Carter. Two days later, they came across two men who had stopped for a rest as they rode their horses near Red Hill Pass, five miles northeast of Fairplay. The avenging brothers ambushed Fred Lehman and Sol Seyga. They fatally shot one and wounded the other but ran the injured man down and finished him off by bashing his head in with a rock.

Lehman and Seyga had been residents of California Gulch, a mining area located near Leadville, just across the Mosquito Range from Fairplay. When word of their murders was received, along with reports of the others, a posse was formed and sent to Fairplay, where they joined up with troops from the Second Colorado Regiment.

Up to this time, no witnesses had remained alive to describe the killers, so the troops and posse had no idea who they were looking for. They rounded up a couple of suspicious characters and tried to induce them to confess by partially hanging them. One of the suspected miscreants was finally released and told to leave the territory, but the other one was hanged to his death. It was not long before it was discovered that the posse had hanged the wrong man.

Edward Metcalf was hauling a load of lumber from Alma to Fairplay when he was surprised by a shot that hit him in the chest. Knocked backward and stunned, it was all Metcalf could do to hang onto the reins as he got a

quick glimpse of the men who were shooting at him. The oxen, which had bolted at the sound of gunfire, took off and didn't stop running until they had gotten out of sight of the gunmen. Realizing that a book he had put in his pocket had stopped the bullet intended to kill him, Metcalf finished the trip into Fairplay on foot, running the remaining three miles. He breathlessly told authorities about the two men who had ambushed him, describing a larger one with a white hat and both with swarthy complexions. The posse again formed and split up to search two different directions to try to track the killers who could now be identified. Tracks of two horsemen were discovered heading south, and the posse went in pursuit. The Espinosa brothers were on their way to their campsite near Fourmile Creek.

Not suspecting that anyone had been able to follow them, the brothers stopped for the night in a dense thicket of willows and cattails. Seven volunteers of the posse waited until after dark before silently creeping in to surround the two, who apparently thought they had escaped once again. One of the volunteers took a shot, hitting Vivian in the back as he stood next to his horse. Another took aim at Felipe, but in the dark, he looked like another of the volunteers, and the shot was not taken. Vivian, mortally wounded but still conscious, fired a few more times but was killed by a shot to the nose, ironically from the brother of Bill Carter, one of the victims. Felipe, realizing that there was nothing he could do to save his brother, escaped into the night.

The posse collected all the items that the Espinosa brothers had accumulated at their camp—clothing, pots and pans, items taken from their victims and a small memoranda book in which entries written in Spanish described the intent to exterminate Americans. Exhausted from their mission, those in the posse left the site to return home, taking all the belongings of the Espinosas but purposely leaving the body of Vivian unburied.

Felipe, on foot and carrying only a rifle, a pistol and the clothes on his back, made his way back to San Rafael. He spent several months in hiding, but unable to do anything to help his starving family, he again went on horseback (no doubt a stolen horse) to return to the campsite where Vivian still lay, by now quite decomposed. He buried the remains but kept one of Vivian's dried and shrunken feet.

Felipe went back to San Rafael and talked his nephew, Jose Vincente Espinosa, into joining him in reviving his quest to exterminate white American men. More murders prompted the commander at Fort Garland to call upon a well-known tracker and hunter, Tom Tobin, to help apprehend the murderers that were creating havoc and fear throughout the area. Tobin was, incidentally, a distant cousin of the Espinosas but felt it his duty to help stop the killings.

Tobin rode with the soldiers as they tracked the two Espinosas into the Sangre de Cristo Canyon. Disappearing into the mountains, the killers eluded the soldiers. Tobin proposed a plan to take only a few men with him as he attempted to pick up the trail of the fugitives. It was mid-morning before he discovered the tracks of two oxen driven by the men. Realizing that he had found them, Tobin and his party quietly followed the signs that eventually led them to a thickly treed area, where they spotted magpies and crows circling a spot nearby. Deducing that the two men had begun to butcher one of the oxen, Tobin directed his men to quietly proceed toward them.

Felipe became aware that someone was there and reached for his pistol, but not before Tom Tobin had discharged his big Hawken rifle, hitting Felipe square in the chest. Mortally wounded, Felipe called out to his nephew, "Escape, I am killed." Several shots were fired toward the younger Espinosa, but it was again Tom Tobin's deadly aim that felled Jose.

Felipe had crawled toward some fallen trees and still had his pistol in hand. He mumbled the word *bruto*, Spanish for "base brutes," as he attempted to fire at his attackers. Tobin reached him and grabbed Felipe's hair with one hand, forcing his head back over one of the fallen trees. He deftly used his knife to remove the head. Tobin directed the rest of his party to remove the head of Jose as well. The date was October 15, 1863.

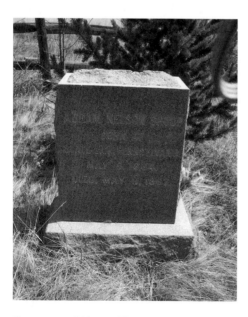

Gravestone of Abram Shoup. *Photo by author.*

The next day, Tobin and the soldiers returned to Fort Garland. Tobin went immediately to the commander's office. "I have got them," Tobin calmly stated. "Got what?" came the response. Tobin then reached into the flour sack he had carried with him, pulled out Felipe's head by the hair and set it on the floor. Again reaching into the sack, he pulled out Jose's head and set it beside the other. It was afterward told that the commander's complexion turned somewhat green at the grisly presentation. It was, however, proof that the master tracker had accomplished his mission.

TOWN TAKES HOLD

During the course of the Civil War, gold mining declined in Colorado. Many of the miners had gone to help fight in the war, and gold had become harder to discover and extract from the ground. Placer mining was being replaced by hard-rock mining, which was considerably more expensive and more complex. A lone miner lacked both the skills and capital required to work the claims. Investors and corporate entities became involved.

The federal legislature enacted a National Conscription Law in 1863, under which no qualifying male (able-bodied citizen between twenty and forty-five years of age) would be exempt from military service. Colorado troops were far from the fray and not called to the front lines, but easterners grumbled that the western territories had become havens for draft dodgers.

Romine Ostrander was a soldier in Company F of the First Colorado. He had enlisted early in the war but now found relatively little to do, so he began to supplement his income by working as a miner in the Fairplay area. He even found time to appear in a play given in Fairplay, which netted a grand total of $51.

The relative quiet of South Park was marred by an incident in 1864 when the Reynolds brothers, among the first miners in the area, hatched a plan to finance the Confederacy with some of the gold that was still being mined. They found out about a gold shipment that would be on a stagecoach on its way to Denver from Leadville. At the stage stop in Como, the Reynolds brothers held up the stage and made off with the gold. They were chased into the mountains by an angry posse, and they prudently decided to hide

their booty. All but two of the gang, including one of the two Reynolds brothers, was quickly captured. A military contingent was assigned the task of transporting the thieves to Fort Lyons for trial. Along the way, the prisoners were encouraged to try to escape, but that ploy having failed, the miscreants were summarily tied to a tree and shot to death. The two escapees headed for Texas, from whence they had come, and were soon in trouble again for horse stealing. The remaining Reynolds brother confessed to the Colorado robbery on his deathbed after having been shot and drew a crude map of the area where the gold had been hidden. Many people thereafter searched the mountainside indicated by the map, but no one has ever admitted to finding the stolen gold dust.

An early arrival to the area, James Castello came from Florissant, Missouri, to explore the Pikes Peak area mining possibilities in 1859 and worked the Nevada Gulch Mine. Formerly a county sheriff in Missouri, he took part in miners' meetings to solve problems that fell to the miners' organization. Castello brought his wife, Catherine, and most of their children to Fairplay in 1863. Soon he was appointed a county judge and served as a senator for the Colorado Territory. James and Catherine operated a hotel in Fairplay that was described as "a spacious log hotel, kept by the genial and loyal Judge Castillo [sic]." Castello's trading post was credited for drawing Ute Indians into town.

The oldest Castello daughter, Lucy, married George Barrett in 1865. Barrett was a freighter in the area and did some mining along the Tarryall River. He owned and ran one of several billiard saloons in Fairplay.

The younger Castello daughter, Mary Julia, married William Beery in 1866. Beery was also a freighter in the area. He obtained a patent in 1867 and perfected a homestead claim on the quarter section in and around which most of the town settled.

Bayard Taylor, in his 1866 notes of *Colorado: A Summer Trip*, described Fairplay as "a quiet little place, with perhaps two hundred inhabitants, at the foot of a wood slope, looking to the south, with a charming view far down the park."

The town was then situated mostly along two parallel streets, Front Street and Main Street. Front Street was the main road north out of town and the one along which most businesses were located.

Fairplay become the county seat in 1867, and the courthouse was moved from Buckskin to Fairplay to a site on Main Street on the northwest corner of the block known as Courthouse Square.

Hugh Murdock owned a store on the east side of Main Street and across Fifth Street from the square, which he sold in 1867.

Henry Hitchcock operated a store on the east side of Front Street, which he sold in 1868 to Aaron Ripley. Nearby, Thomas Cummings had a home, a butcher shop, corral and slaughterhouse. Also nearby, William Coleman ran a billiard saloon. David Miller operated a blacksmith shop (one of several in town), and his wife, Elizabeth, ran a boardinghouse.

Leonhard Summer and his brother Charles first came to Fairplay in 1866 and built a log brewery to manufacture his South Park Lager Beer, which was widely sold in the area.

The McLaughlin Livery on the corner of Fifth and Front Streets was also well known.

Father John Dyer, sent by the Methodist Episcopal Church Council to provide a Christian ministry amongst the miners, first arrived in Buckskin in 1861. He frequently preached in all the neighboring mining communities, as well as in Fairplay. Father Dyer had become familiar in South Park as the "snowshoe itinerant" because of his service during 1864 as a postal carrier over Mosquito Pass. He carried mail in the worst of winter weather, using his homemade skis to negotiate the treacherous pass between Fairplay and Leadville.

In 1867, Dyer, the presiding elder, decided that Fairplay should be the location of a church. While Henry Hitchcock had been generous about arranging seats in his store so that church services could be held there, Dyer objected to preaching underneath a sign that touted "Good Whiskey." He paid $100 for a two-story building that had been used as a hotel in the town of Montgomery, at the base of Mount Lincoln. Another $100 paid for tearing down the structure and transporting the logs to the new site in Fairplay, where it was reassembled at its new site on the south side of Front Street.

A U.S. Land Office began operation in 1867, recording homesteads and mines for much of the surrounding area. Colonel N.W. Owings, an attorney from Indiana, accepted the political appointment of register of deeds in the Land Office. Owings complained that mail contractors lightened their loads by discarding heavy printed matter from their wagons as they traveled over the mountains to the western town.

In October 1868, George Hill, surveyor for the official government township survey, wrote in his report that Fairplay contained about sixty buildings and two hundred to three hundred inhabitants.

Water for the town's use was provided by means of a ditch system, built in 1862 for use in placer mining. The source of the water was a spring feeding into Beaver Creek, which eventually runs into the Middle Fork of the South

Fairplay Ditch map. *Drawn by surveyor W.H. Powless.*

Platte River. Most people used buckets to dip water out of the ditch nearest them—unless it was mid-winter, at which point the water was frozen and they had to go as far as the Platte to get water. Although use of the water for placer mining had diminished, Fairplay residents took water from the ditch system for household use and to water small crops like turnips, rutabagas and barley.

COLFAX BRINGS POLITICS

S chuyler Colfax had been a journalist and was involved in politics in the state of Indiana. He became interested in promoting the development of the West after his election to the U.S. House of Representatives in 1855. Colfax was frequently quoted in the *Rocky Mountain News* for his efforts to expand U.S. mail deliveries to the western territories. Originally a member of the Whig Party, he joined the recently formed Republican Party and in 1865 was elected to the office of Speaker of the House in the U.S. Congress.

Colfax was preparing to take a journey to the West Coast in order to determine the practicality of building a railroad across the continent. Shortly before he was to depart, President Lincoln called him to the White House to talk to him about his upcoming trip. The next day, Lincoln again met with the speaker for a short time as he was leaving to go to Ford's theater to attend a play. Colfax turned down the invitation to go along but was abruptly called later in the evening with the startling news of the assassination.

Nonetheless, he began his western trek, first by railroad as far as he could go and then by stagecoach. Colfax was accompanied by Samuel Bowles, a prominent editor of the *Springfield Republican* newspaper. Events of the trip and many of the speeches delivered by Speaker Colfax were later printed in Bowles's book *Across the Continent: A Summer's Journey to the Rocky Mountains, the Mormons, and the Pacific States*.

Colfax relayed to those gathered to hear him at Central City on May 27, 1865, thoughts that the slain president had wished him to carry to the miners. Lincoln was already planning postwar efforts to heal the nation and

recognized that the sudden influx of discharged soldiers looking for ways to make a living would cause a problem. He told Colfax that he planned to encourage them to head west and work the mines for gold and silver. He predicted that in a few years the unified nation would be "the treasury of the world" and expressed confidence that the gold and silver resources would help pay off the national debt incurred by the war.

Even though the Colfax party was protected by a military escort, they encountered disgruntled Indians intent on stealing and pillaging food and supplies. The Utes had become somewhat peaceful in the mountain areas, but the Arapahoe and Cheyenne who occupied the eastern plains of Colorado were still threatening white settlers. Colfax returned to the nation's capital, convinced that the railroad should be built to link the east to the west.

In 1868, Schuyler Colfax was nominated by the Republican Party to run as vice president along with Ulysses S. Grant, the presidential nominee. Both made extensive campaign trips; Grant was in Colorado in July, and Colfax brought his entourage in August. Colfax brought with him William Bross, then lieutenant governor of Illinois; editor Samuel Bowles; and other personages, including the young lady who would consent to be the wife of the widowed vice presidential candidate.

Thirteen of the hardier members of the group decided to climb Mount Lincoln. Although the trek to the top of the 14,297-foot peak was difficult and the group was greeted with wind, hail and even a little snow as they gasped for breath in the high altitude, they were inspired by the majestic view from the top. Led by Bross, they huddled and shivered together as they sang the doxology, a hymn praising God for His blessings.

Praise God, from whom all blessings flow;
Praise him, all creatures here below;
Praise him above, ye heavenly host;
Praise Father, Son, and Holy Ghost. Amen.

The group descended and traveled to Fairplay, where both Colfax and Bross were engaged to speak. They were well received and continued their tour into Lake County. The party was on its way back to Denver by way of the Salt Works Ranch and found a camping spot near Trout Creek Pass.

There had been rumors that the Arapahoe Indians were again terrorizing the Colorado plains, and Colfax had not forgotten that experience from his previous trip. The group became alarmed when

someone shouted, "Indians!" And there was indeed a band of Indians on horseback heading for the camp. Momentary panic was replaced with great relief when the Indians turned out to be friendly Utes, who had volunteered to escort the party back to Denver. The campfire that evening was remarkable, with speechmaking and the singing of patriotic songs. The Indians were persuaded to add their own songs to the occasion.

Colfax returned to Washington, D.C., to be elected vice president and to marry the sweetheart to whom he had proposed on their romantic camping trip in the Colorado Rockies.

The Illinois lieutenant governor had made such an impression that the mountain next to the one that bore their beloved president's name was given the name Mount Bross, in his honor. Mount Bross is the peak that appears in front of a range of mountains as a traveler heads north on Highway 9 from the town of Fairplay.

Chapter 12
GEOLOGICAL SURVEYS

F airplay has almost doubled in size in the last winter," reported the *Rocky Mountain News* on May 6, 1869, "and many of the new houses are costly and elegant." The *News* opined, "There is some increase in population, but not near what it ought to be. The mines immediately around the town would give profitable employment for five or ten thousand people." The town, although it continued to be widely known as Fairplay, was incorporated in June 1869 under the name South Park City, in accordance with the general laws of the Colorado Territory. The site of South Park City encompassed 320 acres and boasted two "well-kept hotels."

In his *Rocky Mountain Letters—1869*, William H. Brewer wrote that new western towns that are influenced by mining have three phases of their history and growth. First, there is excitement and rapid growth, accompanied by wild speculation and even wilder expectations. Second, there is a time of reaction under which hopes fall and many towns die outright. Third, if the town survives the first two phases, it grows and flourishes as it satisfies the needs of the region in which it has found itself. Brewer was then speaking of Denver, but the observation seems to have been true of many other mining communities, including the town of Fairplay.

William Brewer was a professor of natural sciences at the University of California and a principal in the California State Geological Survey, whose participants explored the Sierra Nevada Mountains in 1864. Brewer and his associate, Professor Josiah Whitney of the Hooper School of Mining and Practical Geology at Harvard, undertook a trip of exploration in the Rocky

Mountains as a project for four of the students who were in Whitney's class and due to graduate in 1870.

Rumors current in 1869 spoke of eighteen-thousand-foot peaks in central Colorado that rivaled those in the Sierra Nevada Mountains of California. The entourage set out to explore the Rocky Mountains and, among other tasks, measure heights of the tallest peaks. Measuring equipment consisted of surveyor transits, barometers, chronometers and boiling apparatus. Brewer carried three barometers in cases that were thought by casual observers to contain fishing rods or guns.

It was known by then that barometric pressure measurably declines in higher altitudes. It was also known that the temperature at which water boils decreases at higher altitudes.

A heavy baggage wagon and four mules, a covered ambulance and two mules and ten riding horses carried the instruments and supplies, as well as the students, their professors and others along for the experience, as they left Denver for their extended field trip into the Rocky Mountains.

An observatory was set up in Fairplay in an unoccupied log house. The nearby camp was located on the stream just below Fairplay. Brewer faithfully recorded his experiences, routinely complaining in the letters to his wife about lost luggage, incessant rains and biting insects. Members of the exploring party climbed and recorded information from Mount Silverheels and Mount Lincoln and then proceeded toward the Arkansas River. There they found mountains that they duly named after their Universities—Harvard, Yale and Princeton—now collectively known as the Collegiate Peaks. They finished up with Grays and Torreys Peaks in the Front Range before they returned to Denver, where they could take a stagecoach to Cheyenne and board the rails to return to their homes in the east.

Of Fairplay, Brewer wrote:

> *Fairplay is a mining town of perhaps thirty to forty houses, just where the Platte leaves the mountains and enters the park. We pass through that, and a mile above pass a most stupendous moraine left by some glacier of former ages, forming a line of hills, perhaps a quarter of a mile wide, and stretching across the valley.*

Just prior to joining his party on their mountain tour, Brewer had incidentally visited the Colorado headquarters of Ferdinand Vandeveer Hayden, which was located about four miles west of Denver. Hayden was then in the initial stages of a preliminary survey financed by the U.S. government that would

ultimately result in a topographic survey of the state of Colorado and the beginning of the U.S. Geological Survey (USGS), which still exists. Brewer noted that the Hayden group was "luxuriously equipped."

After the Civil War ended, the U.S. Congress approved four surveys of the West, all of which overlapped into Colorado. The Hayden Survey established a north–south baseline running through the towns of Greeley, Pueblo and Trinidad. The topographical measurements extended westward into the Rocky Mountains from the baseline. Meteorological observation points were set up at four different elevations: Denver at 5,000 feet, Canon City at 6,000 feet, Fairplay at 10,000 feet and Mount Lincoln at 14,000 feet. The observation point in Fairplay was at the "door-sill of the Sentinel office."

The resulting measurements were compiled and published in the *Colorado Atlas* in 1877. At that point, Colorado was the only state that had a detailed geological map based on the topography of the area. The USGS still publishes the most definitive topographic maps available to the public.

SCANDAL AT THE POST OFFICE

From the *Rocky Mountain News* on July 29, 1870, an article labeled "Summer Saunterings" described something of a travelogue from Denver through South Park and back:

> *Fairplay is a handsome, thriving little town; the county seat of Park County, and has a United States land office. There are two good hotels, and all kinds of supplies can be procured. It is built upon a terrace, a hundred feet above a large branch of the Platte that flows at its foot. The country is all a deposit of boulders, gravel, etc., containing gold in paying quantities. Mining is the chief industry, and gold dust the basis of all business. Looking from Fairplay, it seems in the northwestern curve of a shallow, flat basin—the Park. It is more than nine thousand feet above the sea. There is a seeming narrow belt of timber above it, then the snowy range which appears very low and with easy slopes. Snow banks remain about the town until June, and frosts are not infrequent throughout the summer. Only the hardier vegetables can be raised. The air is delicious and oppressive heat unknown.*

Fairplay was one of the destinations on the itinerary of Erie, Pennsylvania native Annie B. Schenck, who wrote about their "Camping Vacation, 1871," as the party of eight traveled. Annie and her aunt and uncle, along with their four children, were accompanied by a gentleman traveling companion, James Johnson. Their goal was to "take a trip to the mountains and holiday

at the Twin Lakes area, journeying for pure pleasure." The entourage was made up of a wagon drawn by two horses and one saddle horse. They started out from a small town near what is now Morrison and continued over Kenosha Pass. They reached Fairplay on Friday, August 11, to stay at the South Park Hotel, operated by Hugh Murdock.

"Fairplay contains about four hundred people, mostly miners, and is a green little place with one street and the cabins scattered around at every conceivable angle. The views around are beautiful both of park and mountains, but the town is very homely. The hotel table is anything but good, though our rooms are quite comfortable," Annie wrote in her journal.

The next day, Annie, her uncle George, the gentleman companion and a guide that they had hired rode on horseback to the top of Mount Silverheels. Annie was delighted at the chance to taste snow during the month of August and pick wildflowers from the mountaintop.

On Sunday, a day usually reserved for prayer and meditation, Annie and Johnson visited the Fairplay cemetery and reflected that it "counts twenty-two graves, only three persons dying a natural death. On the grave of one was painted, 'Died accidentally. Pray for him.'"

The campers continued their trip, traveling through the Salt Works en route to Twin Lakes, where they spent a week fishing, boating and relaxing. They returned by a different route that took their wagon over Weston Pass, even then a rough road. Not able to reach Fairplay by nightfall, they decided to camp in a valley that looked like a deserted Indian camp. It turned out to be not so deserted, and the party spent the evening in the company of a "couple of squaws and a little papoose" and a number of other campfires.

The next day, the travelers were back in Fairplay, "this homely old town but fortunately in pleasanter quarters. Mr. Murdock's house is full so we are ensconced in a smaller but much nicer abode." Annie attempted to visit an Indian encampment across the stream, intending to get some beadwork to take home. Unfortunately, her horse slipped on a rock in the water, and her foot became entangled in the stirrup as she fell. The horse continued up the bank, dragging her behind. Although she was not hurt, Annie abandoned her shopping intentions as she changed into dry clothing.

The camping party left for their return home, which took them over Hoosier Pass and to Georgetown prior to their final destination back in Pennsylvania.

Unbeknownst to the hardy campers, a scandal was building in the town of Fairplay. On July 20, 1871, a gold package addressed to the postmaster at Denver was mailed at Oro City (a mining town near Leadville). As the mail

came into the post office in Jayne's grocery store the following day, Jayne received the package and prepared the paperwork to send it to its destination on the next stage. The package, valued at $1,260, contained sixty-six ounces of gold dust, as well as checks and currency.

William Beery was a Wells Fargo & Company agent and kept his office in Jayne's building. Beery remarked to Jayne on July 21, "Hello! Another gold package from Oro today?" Jayne replied, "Yes, and a big one, too."

At the end of the day, Jayne and his clerk, a young man named Perry, closed up the store and headed for Beery's home, where they had been invited to a party. Just as supper was to be served, Beery announced that he had forgotten the fruit. He then grabbed a basket and headed to a small stand on the outskirts of town, where he hastily made the needed purchase. He was gone barely ten minutes.

The party broke up after ten o'clock. Jayne went back to his store, which was also his home and sleeping quarters. When he sorted through the outgoing mail the next morning, he found that the gold package from Oro City was missing. As he looked for the package, he noticed that the window on the east side of the store was partially raised. Becoming alarmed that he could not find the package, he went to Beery's house to enlist his aid.

Word was sent to the postmaster at Oro City about the missing package. Arriving at Fairplay, the Oro City postmaster immediately concluded that Jayne was the thief. Vehemently denying the charge, Jayne swore out a search warrant against Beery. At Beery's stable, a piece of twine and remnants of a newspaper were found and identified as belonging to the missing package.

The finger-pointing continued as Beery swore out a search warrant against Jayne. The search party, accompanied by Beery, descended through a trap door in Jayne's store to search the basement. After a half-hour search, the sheriff found a crumpled package with a label that identified it as the one that had contained the gold.

There were now three possible suspects: Jayne, Beery and the clerk, Perry. But there was no evidence that strongly pointed to any of the three men, so the theft was on its way to being forgotten.

The Money Order Bureau of the U.S. Post Office Department sent an agent to investigate. The owners of the stolen property hired two professional detectives. All came to the same conclusion: the theft was perpetrated by one of the three suspects.

Washington officials were not only concerned that a thief had stolen money from a customer of the postal service, they also recognized that their reputation was at stake as a reliable source for transmission of valuables.

Agent John Furay, known for his successes in finding stolen monies and bringing thieves to justice, was called to Denver and assigned the job of solving the Fairplay case.

Furay arrived in Fairplay toward the end of October and began his own investigation into the matter. He attempted to talk to the Oro City postmaster about the theft but got caught in an early snowstorm as he tried to make the trip over the Mosquito Range. Returning to Fairplay and glad to escape with his life, he nonetheless began to assemble the pertinent facts. He grilled each of the three men behind locked doors. He began with Jayne, who despite losing his self-control during the harsh interrogation, finally convinced the agent of his innocence. Perry, the clerk, was next to be questioned. He soon made it obvious to the agent that he had nothing to hide and was similarly cleared. That left Beery.

Known affectionately as "Billy" Beery to the townsfolk, he was the son-in-law of one of the early settlers in town, Judge James Castello. Beery held the office of county treasurer and was the trusted agent for the First National Bank of Denver, as well as Wells Fargo & Co. He had gained a reputation for bravery when he carried valuables for Wells Fargo at a time when the roads were infested with highwaymen and the stages were afraid to run. He was also a cattle rancher on his land located near Currant Creek Pass.

Belligerent at first, Beery challenged the postal agent to prove that he was guilty. After several hours of questioning during which Furay doggedly persisted in his belief that Beery was the guilty party, Beery finally broke down and admitted that he had stolen the package. He agreed to return what was left of the gold dust—about twenty-five ounces—and $100 of the currency, promising to bring the rest, which he calculated to be about $600, to Denver.

Now contrite, Beery confessed to Agent Furay, "At the time, I was terribly pressed for money." He went on to explain how he had planned the party, purposely forgetting the fruit. He actually crawled through the small open window in the store, stole the package and tossed it into an open stall in his own barn before returning to the party. When he accompanied the search team at Jayne's store, he waited until they were in the dark cellar and then threw the envelope across the room as the others were trying to light a candle.

Under advice from his lawyers, Beery deposited the remaining $600 with the First National Bank of Denver. Although full restitution had been made, Agent Furay tried valiantly to see that Beery spent some time in jail for his misdeeds. Beery was successful in evading that end and left Fairplay to work his Thirtynine Mile Ranch on Currant Creek. He thereafter served as an Indian agent before he finally moved to Cripple Creek.

Chapter 14
DESTROYED BY FIRE

The Territory of Colorado acknowledged the importance of mining in the area by appointing a territorial assayer, whose office was located in Fairplay, in early 1872. The Mount Lincoln Smelting Company was erected at the base of Mount Lincoln in the fall of 1872 and was constantly kept running.

The register of the land office reported that, due to new silver discoveries in the area, the town of Fairplay was booming. A $15,000 bond issue was passed in January 1873 to build county buildings in Fairplay, and the "Courthouse Square" was purchased from the town of South Park City for that purpose.

The *Daily Rocky Mountain News* noted the following on January 28, 1873:

> *As has been demonstrated in every mining camp in the mountains, as the population and prosperity of a mining region increases, there is a proportionate increase of crime and also of the business of the courts, which renders it necessary to have increased facilities for the suppression of crime, a place of security for the county records, a place for prisoners, and also a suitable place for holding court—neither of which can yet be found in the county of Park. Fairplay is the proper place for them.*

Harvey Gardiner wrote in his *Mining Among the Clouds*, "Very little snow fell on the Mosquito Range in the winter of 1872–1873. The 'delightful' weather encouraged a building boom in Fairplay that obstructed the main street with building materials in March 1873."

In April, the Town of Fairplay elected new officers: the trustees were James Gibson, George W. Barrett, Josiah Hochstettler, Richard Lee and James M. Cole; the town clerk was W.H. Chapman; the constable was Joseph Castello; the police magistrate was Hugh Murdock; and the street supervisor was Frank Kroll.

In July 1872, Sarah and Addison Janes purchased the land between Second and Third Streets and between Main Street and Castello Avenue. They filed a plat as Janes addition to South Park City in May 1873. Janes was also owner of the grocery, express office and post office located above Murdock's Fairplay House (the same Janes or Jayne involved in the postal fraud).

August Rische came from Prussia to the United States, served in the Civil War and made his way west to Fairplay, where he set up business as a shoemaker on Front Street next to the Methodist Church. In April 1873, Rische filed a plat for Rische's addition, just to the east of Janes addition. Rische came to fame and riches a few years later when he and his partner George H. Hook bargained with H.A.W. Tabor to grubstake them at a carbonate ore mine near Leadville, which later came to be known as the Little Pittsburg Mine. The $17 grubstake, which was reputed to have purchased picks, shovels, food and whiskey, turned into a silver bonanza that netted Rische $262,000 when he sold his interest.

The *Rocky Mountain News* reported in May 1873 that even though the reporter who called himself HEADEN warned those "pilgrims" against coming to Fairplay before the middle of May, many had ignored his warning and come anyway. "A great many 'bum' around town till they get discouraged, and then take the back track; while others get into trouble, and then into jail, and either case invariably cursing the country and the men who have been writing it up."

HEADEN continued his article with a lengthy discussion of all the new buildings that had been built over the winter and were still under construction. Details of sixteen new buildings on the south side of Front Street and eight new buildings on the north side were recorded. The reporter explained that these were just the new businesses and that there were also about twelve or fifteen new residences on Main Street, but the residential owners were probably not thirsting for notoriety. He also noted that the Walker House, a hotel located on the corner of Main and Second Streets, was undergoing construction of an addition.

The article concluded:

> *This is not the spasmodic growth of a railroad town, for there is not a railroad in a hundred miles of here, and neither is it the center of a colony,*

but is simply the result of the development of the natural resources of the most favored region in "Uncle Samuel's" broad domain, and if any other town in the territory within three or four times its size can beat it, we would like to know where they get their lumber.

Gardiner wrote, "The heat and dryness that summer ran hand in hand with the pace of the mining activity. Fairplay, which a year before had been nothing more than an insignificant collection of log cabins, had grown into an embryo city."

At this point, Fairplay boasted a population of nine hundred. Seventy new buildings had been put up in the previous six months. Business lots sold for $12 to $14 per front foot and residential lots $50 to $150 each.

On a Friday evening, September 26, 1873, a few snow squalls had been noticed, the sign of an approaching winter. The cold air prompted Mr. Kebbe and Mr. Hughes, proprietors of Hugh Murdock's Fairplay House on Front Street, to start a fire in the ornate wood-burning stove located in the lobby of the hotel. It wasn't long before the heat from the fire proceeded up the stovepipe into a second-story room in which the canvas covering the ceiling burst into flames. In those days, heavy muslin or canvas was used as a base for wallpaper instead of the lime and sand plaster that came later.

All the buildings in the boomtown were built of wood that came from readily available sources nearby. In their haste to get their establishments occupied before winter, none of the businessmen had thought about fire-fighting equipment.

The fire quickly spread across the street to the Clinton House and then up and down Front Street until most of the business part of town was destroyed. Someone suggested that dynamite be used to check the fire, but most of the available blasting powder was stored miles away at the mines. Although the Middle Fork of the South Platte River ran nearby, there was no method available to convey water to the burning buildings.

By the following morning, all that was left of the business section in Fairplay were heaps of smoldering ashes. Most of the business owners had the foresight to save their cash and records, and banker C.G. Hathaway led the way by opening up the bank the very next day in an unoccupied building not touched by the fire.

Hugh Murdock was a native of Ireland before he came to Colorado and settled in Fairplay in 1864. He owned and ran a store across from the Courthouse Square on Fifth and Main Streets that he sold in 1867. In October 1872, Murdock purchased a lot along with buildings and

improvements on the south side of Front Street just above a store owned and run by Louis Valiton. Valiton had built a new two-story building adjacent to the original main building, a hotel, giving the capacity to serve one hundred guests. There was an office, bar, dining room and kitchen on one side of the lobby and a gentlemen's parlor and reading room, ladies parlor and a number of bedrooms on the other side. In addition to carpeted bedrooms upstairs, there was another ladies' parlor. The building and all furnishings were reduced to ashes.

The Clinton House, on the other side of Front Street, was originally known as Miller's Clinton House, a boardinghouse run by David Miller's wife, Elizabeth. It was touted as the first building in town to have a shingled roof. The Millers sold their boardinghouse and homesteaded what later became the Buyer-Coil Ranch. Meanwhile, the boardinghouse had become a substantial hotel owned by Thomas Freeman and run by Mrs. Cline. The hotel was burned with everything in it.

Leonhard Summer came to this country from Austria in the mid-1860s. He and several brothers were all brewers by trade and began to establish their businesses in Colorado. Leonhard and his brother Charles established

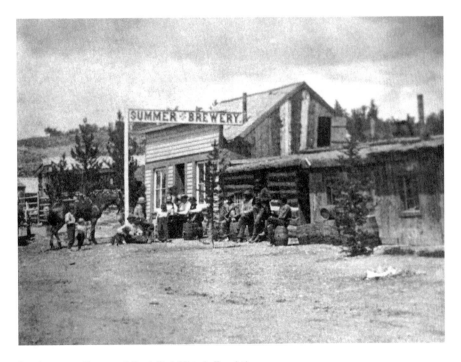

Log brewery. *Courtesy of South Park Historic Foundation.*

a brewery in Fairplay in 1873 after purchasing land along Front Street the previous year. The log structure was the first site for production of South Park Lager Beer, popular with the miners in the area.

The original brewery was totally destroyed in the fire, and Summer was forced to leave Fairplay for a few years and follow other business pursuits until he became financially able to return and rebuild the brewery, this time of native quarried stone.

In the same block, closer to Main Street, the stables of the South Park Stage Line, owned and run by Robert Spotswood and William McClelland, provided stagecoach service throughout the area. Their stables were destroyed, but they were able to save the stock, carriages and harnesses.

Not far from the brewery, George Barrett owned and ran the Pioneer Billiard Saloon. Barrett's father-in-law, James Castello, had built the original structure, a log hotel. When Judge Castello moved to Florissant in 1868, he sold the property to Vincent Albus, along with two billiard tables and a bar with all the appurtenances and fixtures. Several owners later, Barrett took part in the building boom by making a "new building out of an old one, at about double the cost of a new one, but it has improved it decidedly." The building was a total loss.

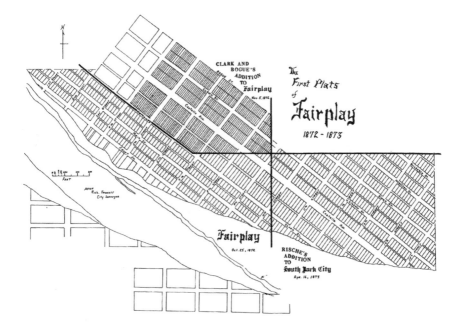

Plat map of Fairplay, 1872–73. *Courtesy of South Park Historical Foundation.*

A few days after the fire, a group of citizens met in Fairplay to organize a committee to collect donations for those who had lost their businesses. Three local businessmen were appointed to head the committee: R.B. Chappel, Fred A. Clark and Judge E. Bass.

A week later, the *Rocky Mountain News* encouraged further assistance from Denver merchants, suggesting that credit be extended to those suffering losses in the Fairplay fire to help them get back on their feet. The Denver Board of Trade established a committee to also collect donations for the Fairplay businessmen.

Back in Fairplay, citizens again met on October 13. It seems that Robert B. Chappel, the chair of the "committee of three," had collected some $1,400 and deposited the monies into his own personal bank account. Very little had been paid out to the sufferers, and neither of the other two committee members had been consulted. The citizens demanded that Chappel surrender his place on the committee and turn over all monies to the newly appointed chairman, John T. Brownlow. No further complaints appeared in the news, so it is assumed that Chappel gave up the money.

CHURCHES AND CHINESE

A lmost immediately after the devastating fire, many of the businessmen and their families left for other locations, but those who remained set out to rebuild the town. Early in 1874, the Colorado Territorial legislature passed an official act to change the name of the town from South Park City back to Fairplay.

Anxious to recover and move forward, a number of the business leaders collected some $1,500 to build a telegraph line from Denver to Fairplay. They petitioned Western Union, then the leading telegraph company, to join with them in the enterprise, citing the need for more rapid communication with local mining operations.

The town completed the construction of a two-story courthouse, using locally quarried sandstone to replace the log building that had been moved from Buckskin when Fairplay became the county seat.

The Methodist Episcopal Church established in 1867 by Father Dyer was one of the buildings that suffered a total loss in the 1873 fire. It wasn't until 1880 that the Methodists again had a minister and began raising funds for a new church and organ. In the interim, Methodist folks used the Presbyterian church and shared a pastor with the Methodist church in Alma. Many of the local dignitaries pledged donations for the new church, which was built and dedicated in 1882.

In 1860, Father Joseph Machebeuf had been sent by the bishop in Santa Fe to establish the Catholic faith in Colorado and New Mexico, where Catholicism and Protestantism were at loggerheads. Father Dyer and Father

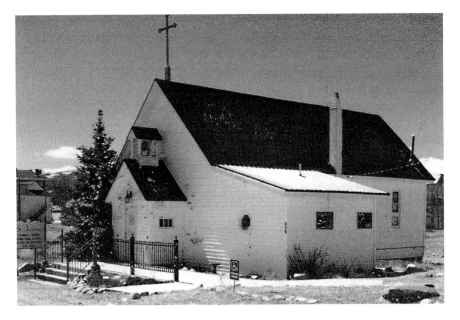

St. Joseph's Catholic Church. *Photo by author.*

Machebeuf both covered the South Park area in their early ministries. Father Machebeuf visited Fairplay in 1863 and 1867. He was seen making his rounds in a large square buggy that was loaded with bedding, cooking utensils, grain and provisions, as well as his vestments and equipment for church services.

The story is told that Father Dyer, while on his rounds in the San Luis Valley, made stops at nearby Fort Garland and Tom Tobin's ranch to hold services. He learned later that Father Machebeuf had extracted a promise from Tobin that only the Catholic clergy would be allowed to conduct services thereafter, as "only they could solemnize marriages or do anything right."

Father Machebeuf supervised the building of St. Joseph's Catholic Church in a residential area of Fairplay in 1874. The church became a mission of the Breckenridge parish and later of the Leadville church.

Meanwhile, a "stubby little sawed-off man with a grizzled beard" representing the Presbyterian mission came to Colorado in 1870. Reverend Sheldon Jackson made a trip by stagecoach to the gold-mining town of Fairplay in 1872 and found a small group of Christian people that inspired him to organize a one-room frame church that was built and dedicated in 1874. Originally named the First Presbyterian Church of

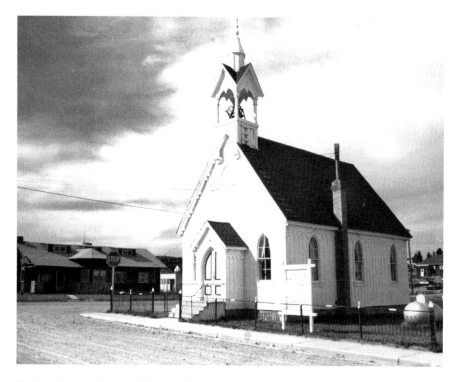

Sheldon Jackson Memorial Chapel. *Courtesy of South Park Historical Foundation.*

Fairplay, the small structure was renamed the Sheldon Jackson Memorial Chapel many years later.

In October 1874, readers of the *Rocky Mountain News* were amused by a story from the *Fairplay Sentinel* about two runaway mules. Billy Jones and John Smith were riding down Front Street in a buggy pulled by two frisky mules when the buggy suddenly capsized, spooked the mules and caused them to take off, kicking, jumping and running as only mules can. The two human occupants were pitched out of the buggy, suffering broken bones in arms and legs. The mules stopped short, but the buggy didn't, and parts of it rained down on various places of business and surprised onlookers. Taking off again, the mules threw even more buggy parts to the wind. Only the bottom and a hind wheel were left as the mules "piled themselves up against a board fence" and finally came to a stop.

Placer mining was now done by large companies who could afford the expensive hydraulic equipment. Frederick Clark and J.W. Smith owned four miles of land and one thousand acres of placers and built a system of ditches and flumes to implement their hydraulic mining process. Operations

required unskilled labor, so in 1875, Clark and Smith contacted Edward L. Thayer to bring in Chinese workers, who would work for less than the local miners. Thayer had been a sailing merchant and had arranged with Chinese companies to find work in the United States for their countrymen.

The Chinese community was established on the south bank of the Platte River, where the original miners had first settled in 1860. The Chinese had a camp right next to the stream, three-eighths of a mile from the edge of the town settlement and on the other side of the gulch farther up. They had a two-story boardinghouse and a number of small cabins built adjacent to one another where they kept gardens and chickens.

The men would report to the tong house each morning to get their work assignments. In addition to working the hydraulic equipment, they developed a system of providing water to the Fairplay residents. Although most people used the town ditch for their water, sometimes the ditch water would get muddy. When this happened, they would purchase the clean water that the Chinese carried up from the Platte River. Coal oil cans were filled with water and then suspended on either side of a yoke borne across the shoulders of the "Celestial" who was delivering water that day.

The Chinese women also established businesses in town. Just above the McLaughlin Livery and Feed Stable, a Chinese laundry was operated by a woman called "Big Mary," while another dubbed "Little Mary" brought lettuce and radishes from her garden to sell. "China Mary" had a studio photograph taken during her residence and is thought to have been the proprietor of a store specializing in accoutrements particular to Chinese customs involving the use of opium.

Although the Chinese kept to themselves in their separate community across the river, elements of bigotry prevalent in that era were frequently practiced. Charles Valiton, the young son of local Fairplay merchant Louis Valiton, told the story many years later of how he and his friends conspired to torment the "Chinks."

The boys went to a gulch where the Chinese were working the hydraulic equipment one afternoon and sneaked through a thicket of willow trees, where they found the end of a pipeline onto which a hydraulic nozzle was attached. The water had been temporarily turned off, so the boys turned the nozzle toward where the men were working. The boys dropped the nozzle and escaped just as the water was again turned on. Young Valiton related, "Looking back a second later, all we could see was flying Chinamen." The pressure of the water had hit a number of the workers and knocked them into the deep pit nearby. The boys thought it was great fun until they noticed

that a number of the Chinamen were following them, armed with big clubs. The young hooligans later learned that several of their victims had been seriously injured.

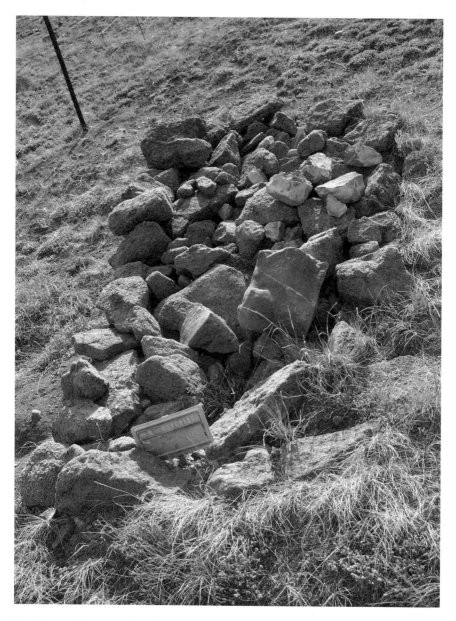

"A Chinaman" grave marker. *Photo by author.*

Mine owner Frederick Clark was killed in 1876 when a guy rope came loose and a derrick fell, pinning him underneath. The hydraulicking operations continued for a time, but many of the Chinese left in 1879 when Thayer contracted for them to work in the King coal mines near Como. A few, however, remained. One who chose to stay was Ah Yot, one of the water carriers. In 1879, an incident was reported in which a stagecoach driver whipped up his horses with the intention of scaring the Chinaman. Not quick enough to jump out of the way, Ah Yot was knocked down, and the heavy Concord stagecoach loaded with passengers ran over him. The driver agreed to pay the medical bills, and Ah Yot eventually recovered.

Besides his water-carrying endeavor, Ah Yot tended his flumes as he prospected for gold. The flumes having been cleaned out by robbers at least five times, the Chinese began to look for clues as to the identity of the thief. Recognizing distinctive footprints, Ah Yot began to suspect Ah Quong, a young dandy known to make his living off others. Angrily, Ah Yot threatened to take care of the matter with his pistol, but the local sheriff appeased him by arresting Ah Quong for the crime.

The other Chinese gradually left, and eventually Ah Yot was the only one remaining in Fairplay. He quietly lived out his years and was found dead in his cabin along Beaver Creek in 1914. There is a grave in the Fairplay Cemetery with a metal marker labeled, "A Chinaman."

Chapter 16

STATEHOOD AND BUSINESS SUCCESS

W hile Fairplay was developing into a thriving town, the Colorado Territorial Legislature had attempted to petition for statehood but had been blocked by President Johnson, who cited a lack of sufficient population. President Grant, however, indicated in his 1872 annual address that he would favor such a proposal. It took until 1875 to get the enabling legislation passed, but local politicians shortly thereafter organized a Constitutional Convention. Thirty-nine delegates assembled on December 20, 1875, at the Odd Fellows Hall in Denver to work out the details of a state constitution.

The Enabling Act stipulated that the state constitution adopt the Constitution of the United States, that no distinction would be made regarding civil or political rights on account of race or color and that the document would not be repugnant to the principles of the declaration of independence. Further provisions included toleration of religious sentiment and a disclaimer of title to unappropriated public lands to the federal government.

Foremost of the issues was whether to include the Deity in the preamble and whether to allow women to vote. The first was resolved by the statement in the preamble, "We, the people of Colorado, with profound reverence for the Supreme Ruler of the Universe…" The second was sidestepped for a few years. A small concession was made to allow women to vote in school elections, but they were not given full voting rights until 1893.

One of the amendments, fairly innocuous at the time, was to establish the beginning of many future arguments regarding water rights. The amendment established the principle of Prior Appropriation—simply put,

the entity with the oldest legitimate claim has the most defensible claim to a water right.

The constitution was submitted for a vote by the people on July 1, 1876, and adopted by a large margin. Although the petition for statehood wasn't officially signed by President Grant until August 1, a July Fourth celebration was planned, and Colorado became the Centennial State.

The delegate from Park County was attorney George E. Pease, who had been practicing law in Fairplay since 1872, along with other mining and cattle business pursuits. Pease was born in Connecticut, had graduated from Yale College, practiced law in Illinois and served as a captain in the Third Illinois Cavalry during the Civil War. While serving as a delegate at the state constitutional convention, Pease was appointed to two committees for the duration of the convention—the Judiciary and the Military Affairs—both of which aptly suited his background.

Meanwhile, the *Fairplay Sentinel* reported in its December 30, 1875 edition a list of the major businesses and their estimated receipts for the preceding year:

> *Beginning with the merchants of Fairplay, we refer first to the O.K. store of M.A. Whiteman, who deals in groceries, heavy hardware, mining supplies, clothing, hats, caps boots, shoes, flour and grain, amounting to $35,000 per year.*
>
> *A. Reichnecker & Co., dealers in drugs, medicines, mill chemicals, perfumery and toilet articles, to the amount of $7,000 per year.*
>
> *W.D. Mackay, druggist, carries a stock of drugs, patent medicines, perfumery, notions and toilet articles, the sales of which amount to $7,800 per year.*
>
> *William Remlin, boot and shoemaker, does a business worth $2,000 per year, employs no workmen, and makes an excellent boot or shoe.*
>
> *Frank Kroll, blacksmith and wagon maker, does a business worth $4,000 per year.*
>
> *Will J. King, dealer in hardware, stoves, tinware, paints, oils, putty, varnishes, sash, doors and blinds, does a thriving business which foots up for the year the snug little sum of $8,500.*
>
> *J.J. Hoover, wholesale and retail dealer in liquor and cigars, reports a business for 1875, of $18,000.*
>
> *Mrs. F.L. Greene, dealer in dry goods, millinery goods, notions, ladies' underwear, her sales amount to $4,500 per year.*
>
> *Jacob Harris, baker and restaurateur, carries on a business amounting to $3,500 per year.*

Joseph Summer, proprietor of Summer's Billiard Hall, does a business worth $3,500 per year.

McClean & McCarter, butchers, deal in all kinds of meats, vegetables and fruits, 8,000 per year.

F.H. Edwards has been in the jewelry, tobacco and notion business six months. His sales have amounted to $2,500.

Peoples' Co-operative carries in stock from seven to ten thousand dollars worth of goods. Sales for the year have amounted to $35,214.17. Probable amount of business for the ensuing year $80,000 to $100,000. Business conducted solely on a cash basis.

James M. Cole, proprietor of the Senate Billiard Hall, reports that for four months the average has been $500 per month, $2,000.

The McLain House, John H. McLain proprietor, reports a business of $14,000.

French's Hotel, Mrs. Ada French, proprietress, $9,000.

The Traveler's Home, Nels P. Danielson proprietor, $6,000.

C.W. McNeal, deals in clocks, watches, jewelry, solid and plated silverware. His sales for ten months aggregate $4,606.

Mrs. A.B. Crook deals in dry goods and ladies' dress goods. In connection with the store a dressmaking establishment has been elegantly fitted up. The business transactions for the year amount to $16,000.

Henry J. Starr, (listed under Groceries) who does a business covering $33,500 per year.

John Cassady, blacksmith and wheelwright, refers to $4,000 as the amount of work done in his shop.

Geo. W. Barrett, proprietor of the Eclipse Billiard Hall, reports his business for the year at $8,000.

James McLaughlin, proprietor of the South Park Livery and Sale Stable, does a business of $28,000; 240 tons of hay and 150,000 lbs of grain were consumed at this stable, which has ample accommodations for one hundred head of horses.

Hugh Murdock deals in fruits, confectionery, fresh oysters, fresh fish, green groceries, etc., and reports his sales for the year at $5,000.

The money order business of the post office foots up the handsome sum of $31,000.

The SENTINEL during the past year has transacted a business of $7,000.

The Park County Racing Association disbursed in purses, building of track, etc., $1,800.

In the Land Office, 166 declaratory statements have been filed. Of these 140 were filed during the last six months; these declarations embrace 29,920 acres of land, the major portion of which lies in Park county. During the last six months there have been 36 cash entries, 17 homestead and 31 mineral entries. Total amount of cash received during the year, $22,000.

The Western Union telegraph company in a town of seven hundred inhabitants, reports for the year $1,943, received for messages transmitted over their lines.

Messrs. Lewis & Co made 50,000 brick, worth at the yard $5 per M, total $2,500.

The brewing business is, as yet, in its infancy, and the proprietor of the South Park Brewery, as per amount of Government stamps purchased, has made ___ barrels of beer, which rivals in excellence the famed brands of Denver.

The survey done by Richard Allen, editor and proprietor of the *Fairplay Sentinel,* compared closely with those businesses listed in the Colorado Business Directory for the year 1876.

Chapter 17

SNAPSHOT OF FAIRPLAY IN 1878

A correspondent of the *Colorado Chieftain* in Pueblo made a trip to Fairplay and Alma and submitted an article about the trip that appeared in the June 27, 1878 edition of that newspaper. Following are pertinent excerpts that describe the businesses of Fairplay at that time:

Fairplay, June 10—My last letter started me on the Denver and South Park railroad for Fairplay. At Morrison, I took a seat in one of the splendid coaches of Spotswood and McClellan for Park County. This firm are among the most enterprising stage men west of the Mississippi River. They have recently put on new stock, and their horses are the very best they could secure in the eastern markets.

The roads were very heavy on account of recent rains, but we made it into Fairplay almost on time. The heavy part of the road is between Morrison and Bailey's, but in a short time cars will be running to Bailey's, and then this will be by all odds the quickest way to get to Fairplay.

At Fairplay, we found excellent accommodations at the hotel kept by Mr. A. Bergh, who stays up till the coaches come in every night and sees that his guests are properly cared for. The Bergh house is deservedly popular with those who visit the south park, and Mr. Bergh is one of the leading Republicans of Park County.

Fairplay is the county seat of Park County and sports two newspapers, the Mount Lincoln News, formerly of Alma, edited by W.F. Hogan, and the SENTINEL, owned by Dick Allen of Leadville, and edited by W.S. Howell, a first-class printer and promising young editor.

Among the old friends of the Chieftain in Fairplay, I must mention Mr. Henry Head, the head man in Jones' store, the principal outfitting place for parties working the placer mines of Fairplay and vicinity.

A short distance north of Head's place is the dry goods and millinery and fancy dress goods store of Mr. Frank Green. His place is headquarters for those wanting any thing in the line of fancy or dress goods, ladies' and children's shoes, millinery, etc.

Further up the street on the opposite side is the South Park Brewery, the property of Sommers & Co. It is in charge of Mr. Leonhard Sommers, one of the best brewers in the state, as the beer takers rank along with Zang's Denver and the Golden beer. Mr. Jos. Sommers keeps a saloon across the street from the brewery, and it is one of the popular resorts of the town. A pretty fraulein nicht longe aus Deutschland sets them up at this place, and the boys all go there when they are thirsty.

A short distance further up the street is the Buckhorn Hotel, kept by Mr. O.J. Cole, formerly of the Red Light Saloon, of Pueblo. He has here a number of the attractions which made the Red Light popular in Pueblo. Jim knows how to conduct a place of this kind and is a popular man in this vicinity.

One of the best appreciated institutions of Fairplay is the banking house of Mr. C.G. Hathaway, opposite the post office. Mr. Hathaway is also express agent and agent for the Northwestern Stage Company that runs from Colorado Springs to Leadville, via Fairplay.

Hard by the bank is the large billiard hall of Mr. Coleman, who now has headquarters at Leadville.

The Fairplay house is presided over by Mr. Joe Castello, one of the best boys in Park County. He is ably assisted by Mr. E.C. Anderson, who ranks at the head of his business as a barkeeper.

Across the street from Coleman's is the liquor store and billiard hall of Mr. J. J. Hoover, a pioneer in his line here and one of the best men in the business in the state. The sample room in the rear of the billiard hall is presided over by Mr. John Nugent, an old Denver barkeeper and one of the best artists in the mixing line west of the Mississippi River.

On the corner next to Hoover's is the post office and dry goods and fancy millinery store of Mr. A.B. Crook, the gentlemanly postmaster of Fairplay. Mr. Crook is also agent for the stage line of Spotswood & McClellan, which runs six horse coaches from the terminus of the Denver & South Park Railroad to Leadville, the new Mecca of all "pilgrims of the rhine."

The rooms over the post office are occupied by the tailoring and dressmaking establishment of Miss Bettie S. Dean, the only tailor or tailoress in the city.

Diagonally across the street from the post office is the large livery, sale and feed stable of Mr. M. McLaughlin, one of the best livery men in the state. McLaughlin keeps a large stock of saddle and driving horses, and has a number of first-class rigs suited to the mountain business. He is doing a splendid business ever since the carbonate excitement broke out at Leadville in California Gulch.

The large general store of Mr. M. Whitman, of El Moro, at this place, is presided over by Mr. Samuel Cohen, one of the most popular business men in the South Park country.

Nearly opposite is the drug, book and notion store of Dr. W.D. McKay, one of the most genial and companionable gentlemen I met in the city. The doctor is the manufacturer of a salve which he warrants to heal up and hair over quicker than any other salve in the market. Near by the drug store is the blacksmith and wagon shop of F.T. Kroll, an old friend and subscriber to the Chieftain.

Farther down the street is the Fairplay House, kept by Mr. Tom Keldef, one of the best boys in Park County. His house is a popular stopping place, and always will be while Tom presides over it.

Across the street and some distance farther up is the office of E. Bass, Esq, one of the leading attorneys of Park County and one of the nicest gentleman I met in Fairplay. The land office at Fairplay is presided over by Judge Henry and Mr. Burchinell, two of Uncle Sam's most faithful public functionaries.

Among the good fellows of Park County I must not fail to mention John Ifinger, the sheriff, now serving his second term and one of the leading democrats of the county.

W.L. Wilson, the county treasurer, is also among the popular men of Park County, but for genuine good fellowship, commend us to Mr. Ed B. Hepburn, county clerk and recorder.

Gulch mining is being prosecuted with a great deal of vigor in the vicinity of Fairplay and Alma the present season. While the streets of Fairplay and Alma are not exactly paved with gold in the manner of the New Jerusalem, the ground is full of gold and yields, where worked, an average of forty cents to the cubic yard.

RAILROADS AND TELEGRAPH

A s early as 1853, dreams of a transcontinental railroad were in the minds of Americans. Their plans were brought up in Washington, D.C., where vigorous debates came from the halls of Congress. The federal government sent corps of engineers west to survey possible routes across the country, over the mountain ranges to the Pacific coast. Several were found, but different factions disagreed about which one should be chosen. A draft of the Pacific Railroad Act was produced in 1856. When the Civil War began, several powerful southern congressmen, who preferred a more southern route, withdrew from the debates. The northern congressmen then chose a more northerly course that took them through the southern part of Wyoming, which provided a less rigorous route across the Continental Divide than through central Colorado.

The first of eleven Pacific Railroad Acts was approved by Congress on July 1, 1862. It read: "An Act to aid in the construction of a railroad and telegraph line from the Missouri River to the Pacific Ocean and to secure to the government the use of the same for postal, military and other purposes."

The second Pacific Railroad Act, passed on March 3, 1863, established the gauge of the tracks at four feet eight and a half inches, considered to be the standard gauge.

In 1867, the Union Pacific, which had been chartered by Congress to build the eastern part of the new line, was laying track through the new city of Cheyenne, Wyoming. Entrepreneurs from Denver and Golden vied to get a line from their respective cities north to Cheyenne.

Denver leaders organized a board of trade to sell stock subscriptions to cover the cost of the line between Cheyenne and Denver. Territorial governor John Evans, who had succeeded William Gilpin in 1862 and held that office until 1865, was instrumental in securing the federal land grants and county bonds for the Union Pacific line from Cheyenne to Denver, and it was completed in June 1870.

Meanwhile, the Kansas Pacific Railroad had been building westward toward Denver but ran out of funds while construction was somewhere in western Kansas. By August 1870, the Kansas Pacific had managed to find additional funds and completed their line into Denver. In September, a short line was completed between Denver and Golden. Denver was now connected by rail with the influential East.

Also in 1870, the Denver and Rio Grande launched a project to take their narrow-gauge (tracks three feet wide) railroad south from Denver to Mexico City. By 1872, that line had extended through Pueblo to the coal fields near Florence.

Former governor John Evans and his local Denver associates organized the Denver & South Park Railway on September 30, 1872, with a goal to reach the Fairplay and South Park gold fields. The company was reorganized in June 1873 as the Denver, South Park & Pacific Railway Company (DSP&P). The narrow-gauge line was completed as far as Morrison in 1874.

At Morrison, passenger traffic and the mail were picked up by stagecoach and forwarded to Fairplay. The South Park Stage Line, owned and operated by Spottswood and McClellan, had obtained the mail contract. Their stagecoach business located in Fairplay, they were reputed to be old and experienced stage men, and just the men to own, manage and run such a line of coaches.

The Panic of 1873 was caused by the failure of the country's biggest investment firm, which had handled most of the federal government's wartime loans. The resulting depression lasted until 1878 and effectively curtailed much of the nation's business activity, including the expanding railroads.

Silver discoveries near Leadville helped revive the local economy. Now the race was on, and a number of railroad lines competed to get their service into Leadville, just over the Mosquito Range from Fairplay.

Fairplay's George Pease took issue with the Denver, South Park and Pacific Railway for not building its railroad fast enough. Evans responded by assuring the public in a letter published in the *Denver Daily Times* on June 5, 1874, that the railroad company was moving as fast as possible and was depending on revenues from the current operations to finance

expansion to Hall's Valley, Hamilton, Fairplay, the Salt Works and on to the Arkansas Valley.

Railroad promoters had largely followed a policy of building their lines to company-owned town sites, usually located a few hundred yards from the outraged older communities. If the landowners, settlements or towns along the line did not provide right-of-way or depot grounds on terms that suited the railroad, they would be bypassed in favor of others who met their terms.

The Fairplay community favored a direct route to Leadville through the Mosquito Range that would require blasting a tunnel through the mountain. When the cost estimate came to $4 million, that proposal was pretty much scrapped.

DSP&P engineers who had originally surveyed the main line showed a route that led through Hamilton and Fairplay. When further surveys were done, the route was changed. Tracks for the DSP&P would now go through the Red Hill station, extend southerly to Garo (Garos on railroad maps), over Trout Creek Pass to Buena Vista and then to Leadville. Reasons for the change given were the timeline (they wanted to get to Leadville as fast as humanly possible) and the terrain, which was somewhat rougher northeast of Fairplay.

The Fairplay-Alma branch, approved by the DSP&P board of directors in October 1880, would extend north from Garo and around the town of Fairplay on the northeast to the mines near Alma.

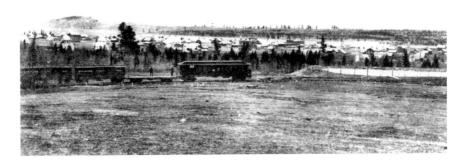

Denver, South Park and Pacific with Fairplay in the background. *Courtesy of South Park Historical Foundation.*

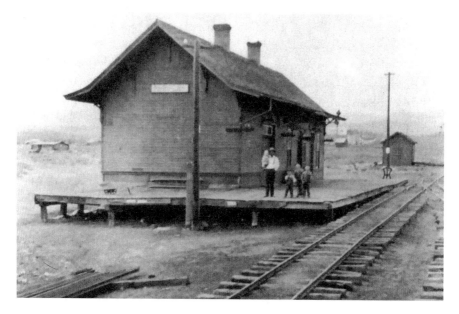

Fairplay Depot. *Courtesy of Bob Schoppe Collection.*

The first Fairplay depot was built in 1881. Articles in the *Fairplay Flume* on September 22 of that year stated:

> *Mr. Root, the traveling auditor of the South Park road, says the Fairplay station will be established and ready for freight and passenger traffic next Tuesday.*
>
> *A great deal of freight is being delayed on account of shippers waiting for the opening of the Fairplay depot. An official announcement of that event is expected in a few days.*

Along with the railroads, a necessity was created for telegraph lines. Train engineers needed to know if and what other trains they would be encountering, and immediate communication was essential. The March 20, 1879 *Fairplay Flume* told of the progress of telegraph lines from a *Denver News* article:

> *Workmen are now engaged in putting up telegraph lines in Platte canon, to follow the line of the Denver and South Park railroad to Leadville. This is a much needed improvement to the telegraph company, the railroad and the public. The line now follows the road and is consequently more difficult of access than the new line will be. The railroad company experiences*

difficulty from the lack of all telegraphic facilities between Bear Creek and Bailey's. The public generally will be benefited in that the present liability to damage will be decreased. Hardly a day now passes without an accident to the Leadville line, and although the break is always discovered and repaired in the shortest possible time, the inconvenience caused to business is very great. Two wires will be put up instead of one. A duplex machine, similar to that now in use in connection with Kansas City and Cheyenne, is also talked of.

On April 22, 1880, the *Flume* reported:

The completion of the telegraph line from Red Hill to Fairplay gives a double means of communication with the outside world. The annoyance of not being able to reach Leadville, Denver or other points at a moment's notice on account of this place being "cut off" on the Western Union wire has been so frequently felt that we feel sure the new line will be welcome to all. The office is in the Vestel House and for the present M.J. Bartley will send such messages as are entrusted to his care.

Chapter 19

JUSTICE

The two-story red stone courthouse built in 1874 stood in the center of the block designated as the Courthouse Square. The jail in the basement of the building perpetually housed one miscreant or another, while the second floor was home to the district court in which cases were heard and decisions of guilt or innocence made.

John J. Hoover was seemingly a pillar of the community as a local business owner and a duly elected member of the Fairplay Board of Trustees. He had, however, suffered some financial setbacks and was trying to keep his business afloat during the early months of 1879. The Cabinet Billiard Saloon featured wines and liquors, cigars and tobacco, in addition to the billiard games. There were at least three other establishments in town that similarly catered to a favorite pastime of the town's male occupants.

The town board of trustees held its regular monthly meeting in March 1879, at which two items were considered. The first was to approve an order that the town ditch be opened at once and kept open during the season. The second was to appoint Sheriff Ifinger to fill the vacancy of the office of constable pending the next election. Both were to have particular significance to John Hoover.

The Fairplay House, located at Sixth and Front Streets, was run by John McLain at the time. Hoover lived with his wife, Euphrasia, in a house on Front Street located near the hotel. On the first day of April in 1879, Thomas Bennett, hired by McLain to clean out the ditch where it ran by the hotel, had blocked the ditch and was in the process of removing debris. For some

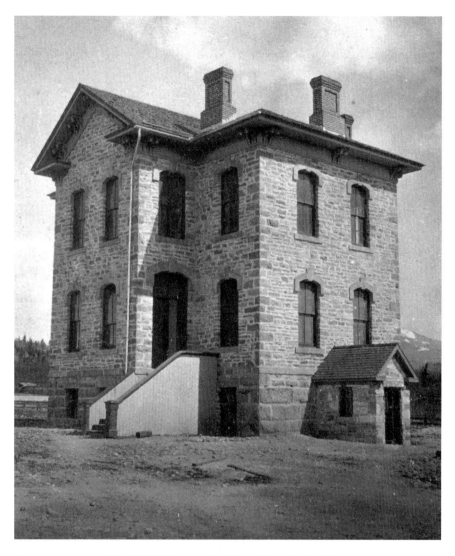

Courthouse, circa 1880s. *T.C. Miller photo from Ed and Nancy Bathke Collection.*

reason, he stopped his labors and went into the hotel. Meanwhile, the water from the ditch had overflowed and was heading toward Hoover's house.

Several witnesses at the hotel reported that Hoover came up the porch and into the hotel about 1:30 in the afternoon on that day. He confronted Bennett, who was standing next to the counter. According to one witness, Hoover said, "I want you to understand that I own that house and lot over there, and I am a going to run it, and I won't have you nor no one else insult

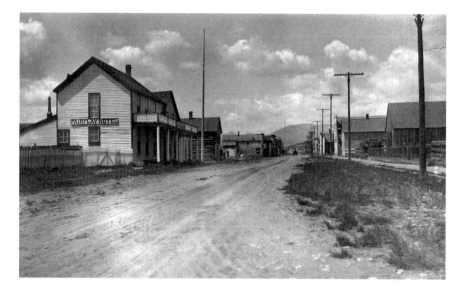

Front Street Fairplay House. *Courtesy of Isaac S. Smith family.*

my woman." Bennett reportedly replied, "Mr. Hoover, I don't want to insult you or impose on no one."

At that point, Hoover drew out his handgun, later described by Sheriff Ifinger as a "double action 38 caliber six chambered Colts revolver." Shooting Bennett point blank in the chest, Hoover uttered some profanities and made more threats until another witness protested, "For God's sake, don't shoot him again!" Hoover then turned around and left the hotel.

Bennett was carried to one of the rooms and Dr. Ramey summoned. The doctor didn't arrive until about 9:00 p.m., and by that time, the victim had succumbed to his wound. In the meantime, several witnesses had talked with Bennett about the incident and asked if he had done anything to provoke the shooting. Bennett was heard to reply, "No. No. No. Oh my God, he did it in cold blood!"

Sheriff Ifinger found Hoover at the Cabinet Billiard Saloon and took him into custody, along with the pistol he had used. A few days later, the sheriff took him into Denver for incarceration pending his trial.

A year went by before the case was finally scheduled for hearing at the Park County Courthouse in April 1880. Hoover tried to get a further delay, citing that witnesses on his behalf were not available and that his attorney had died, forcing him to retain another. His statement contained a plea that he had been subject to temporary fits of insanity and mental derangement

since his fall into a mineshaft in 1871. The case was scheduled for April 27, 1880, and would be heard by Judge Thomas Bowen. After hearing the evidence, Judge Bowen found Hoover guilty and sentenced him to eight years of hard labor at the penitentiary in Canon City.

Around three o'clock the next morning, Sheriff Ifinger was awakened at his home by an unruly mob of masked men demanding the keys to the jail. The sheriff refused, and the mob then moved over to the jail in the basement of the courthouse, where they again demanded the keys. Again refused, the masked mob broke into the jail. They forced the prisoner up the stairs to the second floor and quickly pushed him out the window with a noose around his neck. When the sheriff arrived at the scene, the mob had departed. Ifinger and the jail guards took the body down and removed the noose. All later swore that they could not identify any of those in the party that did the hanging.

On April 28, another trial had been scheduled—that of the *People vs. Cicero Simms*.

Only a few months back, on January 25, Simms and John Janson had been playing friendly games of cards on a Sunday afternoon. After supper, they were talking and sparring as young fellows do in front of Link's saloon in Alma. At some point during the horseplay, Janson knocked Simms's hat off. Simms demanded that the hat be picked up and replaced. When Janson did not immediately comply with the demand, Simms pulled a revolver out of his pocket and shot his friend in the forehead.

As bystanders began to react, Simms backed away from the scene and then turned around and ran. It was only a few days before he was found at a boardinghouse in Denver and arrested. He was in the Park County jail the night that the angry mob broke Hoover out and gave him a dose of vigilante justice.

Judge Bowen became aware of the undercurrent of gossip as he conducted the trials scheduled for that day. Simms was found guilty and sentenced to hang. Other cases were on the docket, but the judge, perhaps because his wife had traveled with him and heard about the grisly proceedings during the previous night, decided to cut his stay in the county seat short and left without finishing his caseload.

Although Simms's attorney tried to get the governor to reduce the sentence, the decision was upheld. On July 23, 1880, a special carriage was sent to the door of the courthouse to pick up Cicero Simms. He was transported a block away, where a scaffold that had been constructed in the area the town used as a baseball field awaited. The sentence was carried out

in the presence of Simms's two brothers, who had come to be with him in his last hour.

The *Fairplay Flume* covered the event using the entire front page of the July 29, 1880 newspaper. The reporter observed:

> *Although within a year Park County has been the scene of several murders…*
> *the execution of Simms is the first instance in which a Park County murder*
> *has suffered the death penalty. The first public execution in Park County is*
> *a thing of the past, but its wholesome influence still remains and will work*
> *a healthy sentiment among would be transgressors of the law.*

Later that same year, the new county jail was constructed near the courthouse. However, there would not be another instance wherein a public execution was held in Fairplay.

FAIRPLAY INCORPORATED

In July 1880, an election was held, and the people in Fairplay voted to become a municipal corporation under the Colorado Towns and Cities Act.

The Fairplay Town Hall Association, an enterprise started by several of the local businessmen, also incorporated in 1880, and construction began on a hall building on Main Street in the same block as the Bergh House, a popular hotel. The building known as the Town Hall was designed to accommodate concerts, dances and public meetings. On opening night early in November, the Fairplay Cornet Band was featured, with a grand ball afterward.

The county courthouse had been built in 1874. In December 1880, a fire started in a wood box in the county judge's office and nearly burned down the courthouse. But within five minutes of the alarm, one hundred men were at the scene and quickly put out the blaze. The legal records were somewhat scorched but still legible. Local resident and businessman Thomas Sykes was in town the day the courthouse caught fire and was among those who responded. He described the efforts to put out the fire using a bucket brigade.

The county commissioners opted to build a jail nearby but separate from the courthouse. The jail had been located in the basement of the courthouse until that year. The new county jail was completed in 1880 and contained two cells with a lock-down mechanism in the small front area.

The two-room schoolhouse on Fourth and Front Streets was replaced in 1881 with a two-story building of red sandstone at Sixth and Hathaway Streets, where it stands today. The old schoolhouse was converted into a

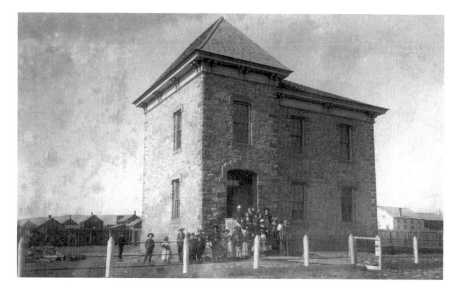

Edith Teter School, 1880s. *Courtesy of Philip A. McKee and family.*

store, after extensive remodeling, and later moved to another site and used as a dwelling. After the original schoolhouse was moved in 1883, the lot it had occupied was sold to the Town of Fairplay.

Town ordinances were approved in 1882 to establish punishments for those who would "willfully disturb the peace or quiet of any neighborhood"; "any person who shall make an assault or battery"; "any grocer, saloon-keeper, inn-keeper who shall keep an ill-governed, lawless or disorderly house"; and "any person obstructing the marshal or any officer in the performance of [his duties]."

Ordinances were also established to require a license that cost $500 for anyone to "vend spirituous, vinous and malt liquors." Permits were granted to druggists for sale of the same items in smaller amounts for a much-reduced cost of $50. If the operator of one of those businesses failed to pay the fee and was fined, he either paid the fine or was "committed to the town calaboose or county jail, and adjudged to work out by laboring for the town under the direction of the marshal, not exceeding ten hours each working day, for which he shall be allowed two dollars per day." In 1883, the liquor license fee was reduced to $100.

The town ditch had served thus far as the source of water for most of the town's occupants, but in 1882, the town board appointed Charles Wilkin as town attorney, whose first task was to get financing for a new waterworks. To fund the project, a bond was approved in the amount of $10,000 payable in

Fairplay Reservoir, early 1900s. *Courtesy of Wilkin Collection.*

ten years. A reservoir was constructed on the northeast end of town adjacent to the ditch that brought water from Beaver Creek, and a system of pipes was installed to distribute water to the residents and businesses.

The new waterworks provided an added benefit in improving the town's firefighting ability. The Coleman Hose Company was organized and a new hose house built on the site purchased by the town in 1883 after the schoolhouse had been moved from it. Volunteer firefighters trained frequently and participated in tournaments with other towns to show off their skills. When the waterworks was built, hydrants were installed so firefighters could use their hose carts with pressure enough to reach any house in town.

In January 1884, the waterworks was tested with a fire that was thought to have started from sparks blowing from a neighboring chimney. Reichenecker's and Cohen's store buildings on Front Street suffered losses, but the fire was contained to those two, as the firefighters were able to run hoses from the newly installed hydrants.

The hose house also served as the official town hall, where the town board of trustees met and elections were held. There was a town jail in the back of the hose house that had fallen into disrepair by the 1890s. The town had a contract with the county to use the county jail until 1894, when the county commissioners decided that the five dollars per quarter paid by the town was not enough to offset the risk taken when mixing the prisoners.

In 1881, the London Mine had installed new mining equipment that included that new phenomenon of communication, the telephone, which connected the mine with their offices in Fairplay. Although the mine enjoyed the convenience of the telephone early on, the service wasn't available to the public until 1888, when the Colorado Telephone Company began installing the poles for telephone wire. The line then ran via Morrison, Bailey, Webster, Como, Fairplay, London Junction and Mosquito Pass, following closely the old stage line.

Late in 1889, the board of county commissioners agreed to purchase the property of James Gibson at 550 Castello Street to establish a hospital "for the purpose of taking care of the paupers of Park County." Gibson was reimbursed six dollars per week for each patient that was taken care of at the facility.

In 1893, it was reported that McClure, then the warden of the hospital, accompanied "an imbecile woman" who had been a charge of the county for nearly a year to Denver so that her Pennsylvania relatives could secure her a home in some asylum.

In the fall of 1894, a local resident found another hospital inmate about a mile and a half above town lying under a large tree wearing only scanty clothing. He had escaped from the county hospital a few days previously. A wagon was dispatched to return him to his room, and precautions were taken to prevent any further incidents.

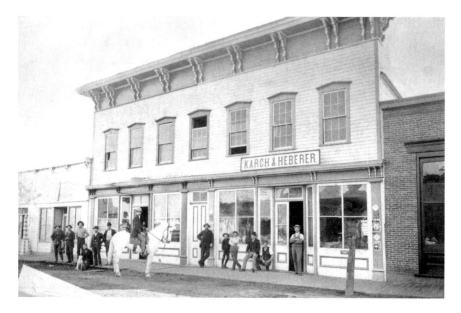

Karch & Heberer store on Front Street. *Courtesy of South Park Historical Society.*

A lengthy article in the January 5, 1899 edition of the *Denver Weekly News* was headlined, "Fairplay, One of the Oldest Towns in the State." The article described Fairplay, the county seat of Park County, with a population of seven hundred. The reading public was told of the large grocery and general miners' supply store run by Karch, the mayor, and Heberer, the president of the school board. A local hotel, the Fairplay House, was run by J.A. Klein, and the livery stable and corral was owned and run by H. Bergstrand. George Teter served as the wagon maker and blacksmith. Sam Cohen and his family ran a mercantile store, and William Hill operated the Board of Trade saloon and billiard parlor. The local newspaper, the *Fairplay Flume*, was edited by George Miller, a young lawyer active in local politics.

THE SUMMER BROTHERS

With a revival in the mining industry nearby and railroad traffic firmly established, Fairplay was set to become a permanent town.

The *Fairplay Sentinel* editor had pulled up roots and gone to Leadville. The *Fairplay Flume* began operations with its February 20, 1879 edition and still publishes a weekly newspaper. During its first few months, the *Flume* occupied a building on Front Street that was built by Joseph Summer. Joseph's brother Leonhard Summer had suffered the loss of his brewery in the 1873 fire and left town for several years to work in the barley business. When he had accumulated enough capital, he returned to Fairplay and rebuilt the brewery in 1879. During that same year, Leonhard Summer built the Summer Saloon on Front Street near the brewery. It was in competition with Summer's Saloon, located directly across the street and built and operated by his brother Joseph.

Joseph and his family lived in rooms at the rear of his saloon. The Summer family, except for Joseph, who had gone to Denver, was listening to a band in their saloon one Friday evening in May 1879 and apparently did not hear anything going on in the back rooms. When they retired for the night, however, they found that someone had cut out a pane of glass next to the lock in which the key was kept. Checks and money had disappeared from concealed locations, which indicated that whoever had done the stealing knew where to find the valuables.

Joseph had a quiet talk with Deputy Sheriff Greene, and they both did some investigating. One of the saloon's patrons, Charlie Murray, was

suspiciously spending money while claiming to be "strapped" for cash. Murray was about to leave on the stagecoach when Greene tapped him on the shoulder and told him to hold up a while. A search revealed that Murray had $69 in cash and had sewed one of the stolen checks into the lining of his coat. He was bound over to the district court, and his bail was set at $300, which no one tried to raise.

Joseph had built a hotel near the saloon, known as the Victor hotel, and had attempted to start up other saloons and then to sell his properties in Fairplay. In June 1883, he was operating a saloon in Como. One night in mid-July, he was seen in his Como saloon as late as two o'clock in the morning. At five o'clock that same morning, he was found dead, lying in a pool of blood with several wounds on his forehead. Physicians concluded that he had been bludgeoned with a revolver. Other reports claimed that he had committed suicide by butting his head onto a railroad tie. That version seemed unlikely, as no railroad ties nearby could be found with either hair or blood, and it would seem to be fairly difficult to ram one's own head hard enough to cause death. At any rate, the case was dropped, and no further investigation was attempted.

Joseph's widow, Agatha, attempted to run the hotel for a while but remarried in 1885 and moved away from Fairplay. Meanwhile, Leonhard continued to operate his brewery on Front Street and frequently advertised his products in the local newspaper. South Park Lager Beer was a favorite in area saloons, as was Bock Beer.

By 1892, Leonhard had leased his brewery to Mr. Eckert and Mr. Gebhardt. On a Saturday morning in August, the lessees had been brewing up a large batch of beer, and the machinery was well heated. A fire broke out in the chimney and, when discovered, had reached all parts of the roof. In spite of the efforts of the local firemen, the building was a total loss, as were the contents. Leonhard, having experienced the loss of his brewery in the 1873 fire, was careful to have insurance, as were the lessees.

Not to be daunted, Leonhard immediately began to rebuild the brewery, this time with the same native red sandstone that was used for the courthouse. Although the brewery was rebuilt, Leonhard could not recover from the financial setbacks that he had suffered. The Panic of 1893 affected him as it did the entire country. By 1897, he had turned the Summer Saloon into a meat market and was selling groceries as well as meat. He had gone to work as jailer for Park County and had made the brewery into a rooming house. In June 1900, Leonhard advertised, "For Sale or Lease, all my property; including saloon, meat market and

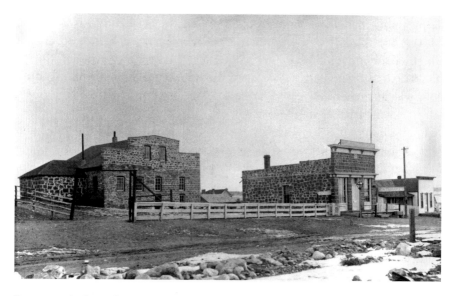

Brewery and saloon. *Courtesy of Tom Klinger collection.*

hotel." He apparently had taken possession of the saloon and hotel that his brother Joseph had left.

Then, just before 6 o'clock on the evening of September 10, 1900, a local merchant and friend, Joseph Sykes, went to Leonhard's saloon to ask him over to supper. Sykes found the despondent businessman in a pool of blood behind the bar, unconscious. There was a .44 Bulldog revolver in his right hand and a razor tightly clutched in his left hand. He died the next day without regaining consciousness.

Leonhard's daughter Adelia, who had been appointed administratrix of the estate, attempted to sell all his properties in 1907, but the market at that time was so poor that she had to re-offer the properties. They finally were sold, albeit at extremely low prices.

A CENTURY TURNED

H ydraulic mining was practiced near Fairplay in the 1870s when the Chinese were hired to work the hoses. The method was revived early in 1900 by the Cincinnati Gold Placer Mining Company, which purchased eight hundred acres of land south of the town near the river where the gravel was found to still contain promising quantities of gold.

The hydraulic process was now more complicated than hosing down the sides of the riverbanks. An intricate system of flumes and culverts was built under the county road and railroad tracks and immersed several feet below the water level. A hydraulic elevator was brought in. The elevator was a huge suction device powered by a source of water that dropped several hundred feet to provide enough pressure to force the gravel from under the stream bed upward through the pipes, which were two or three feet in diameter. The gravel was directed by water pressure through a series of sluices where the gold, heavier than the gravel, was caught in the riffles and retrieved.

During the process of putting in ditches, the placer workers had to build a ditch underneath the C&S railroad track. The railroad foreman, William McKee, heard what they were doing and took his "special" along the track to the site where they were working to investigate the progress. McKee discovered that the men had removed a portion of the track and were aided by a keg, which was no doubt increasing their enthusiasm for the job at hand. McKee reportedly devoted his untiring energies for the remainder of the day to repairing the damage to the track and making sure that there would be no chance of discovering another keg.

The Cincinnati Gold Placer Mining Company and the Gold Pan Placer Mining Company, located in Summit County, kept a number of men employed for several years during the summer seasons. By 1905, the returns had grown small, and the process largely diminished.

Lode mining was still producing gold and silver ores that were sent to local smelters for processing. The London, Orphan Boy and Moose Mines were among the most productive.

By 1903, telephones were becoming established in Park County, and the Colorado Telephone Company had set up its telephone exchange office in the Owl Drug Store on Front Street. Switchboard operators were hired to make the phone connections from the exchange.

The waterworks system provided an alternative to hauling water from the ditches. Water mains and water supply pipes had been installed to run water from Beaver Creek and the Fairplay Reservoir into the homes and businesses of the town. During the winter months in late 1902 and early 1903, the level of water in the reservoir became so low that the town board found it necessary to shut off water to the people in order to maintain a level that would adequately serve fire protection. This resulted in frozen pipes and a lot of maintenance on the water system. The next two years, the water level was maintained without the shutoff measures. It was the job of the town marshal to oversee the reservoir level and issue edicts as to water use.

1903 also marked the installation of a new street lamp in front of the hose house. It was touted as a gasoline lamp of the latest type, with 2,400 candlepower, lighting the street for several blocks. This era also marked early attempts to establish a public library. Fundraisers were held to purchase books, and the library was set up at the school. Local patrons had limited access, as the library was run by students and only open during school hours. A six-piece orchestra was also organized, and its members performed at the Town Hall, giving a number of concerts for the public's enjoyment.

A baseball team demonstrated the enthusiasm throughout the area for that pastime. Competition was stiff, with teams from Breckenridge, Hartsel, Como, Buena Vista and other local teams anxious to prove their prowess at Fourth of July celebrations. The Fairplay team originally wanted to order green uniforms but changed to blue after they were told that the color would fade less. The team became known as the "Boys in Blue." The popular local pitcher tested the local sense of humor at one game when he pitched a large potato instead of the ball. The batter connected and sent the ball over the head of the third baseman. The runner made it to home plate but was tagged out. When everything got sorted out and the umpire was called upon for a

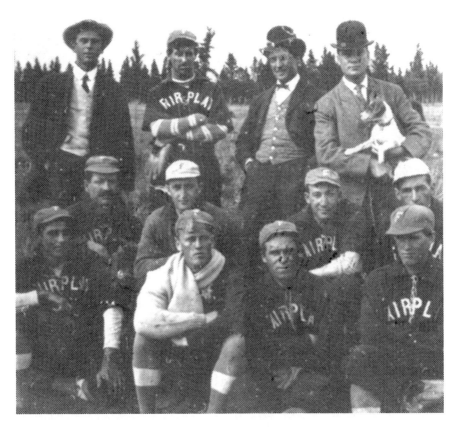

Baseball team in the early 1900s. *Courtesy of South Park Historical Society.*

decision, he declared that "sorting spuds and playing ball were governed by different sets of rules." The whole play was officially disregarded. The next summer, a grandstand was erected at the baseball grounds on Castello Street between Third and Fourth Streets.

The town jail, though it had become very shabby, was still used as a method of incarceration for local miscreants. One such inhabitant was suspected of arson when in July 1904, the jail suddenly exploded late in the night and burned to the ground. Since there was no stove in the tiny building and the fire was described as definitely incendiary in origin, the most recent and frequent occupant, Andy Ryan, was thought to have purposely removed any temptation to again lock him up.

The town board didn't take long to decide that the jail needed to be replaced. The Summer Brewery was considered, since it was currently standing empty

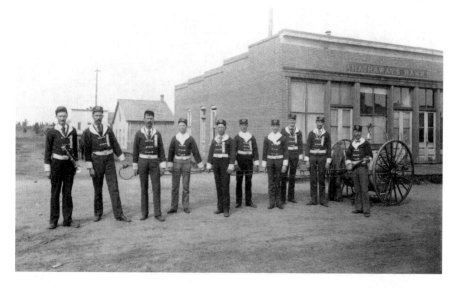

Firemen in front of Hathaway's Bank on Front Street. *Courtesy of South Park Historical Society.*

and unused, but plans were instead made to build a new structure in the same location behind the hose house. The new jail was completed in December. The *Flume* reported, "The new town jail has been completed. It is a stone structure, and judging from its size, most any hobo who incurs the displeasure of the town marshal is apt to find himself in close confinement."

In May 1905, a fire caused by a defective flue in a local cabin was efficiently put out. Nevertheless, the editor of the local newspaper was prompted to comment about the lack of a good volunteer fire department. He challenged the young men of the community to become more involved.

That October, a fire was discovered at the C&S Depot, apparently from an engine spark. The volunteers quickly responded but discovered that they were some two thousand feet from the fire hydrant and carried only six hundred feet of hose.

Less than two weeks later, a call came from Alma for help with a fire that had gotten out of hand in the neighboring town. As soon as the call was received, volunteers assembled in Fairplay and gathered what equipment was available. They departed for Alma using any means of transportation they could find, a number of them arriving in their own buggies. The twenty-five or thirty volunteers from Fairplay helped save a number of buildings threatened in their neighbors' town. This demonstrated the existence of a willing and active mutual-aid program, a principle that continues today.

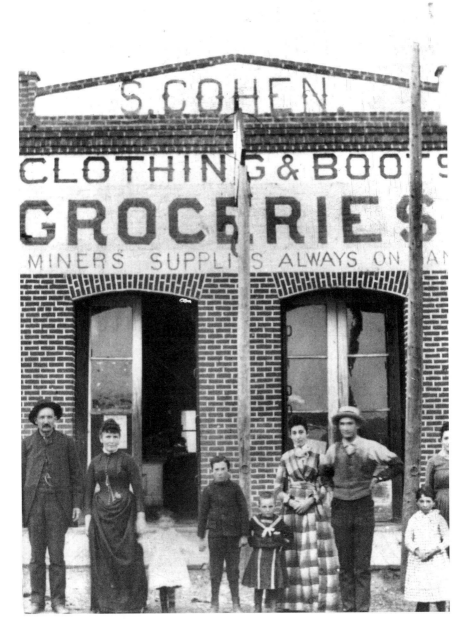

Sam and Eva Cohen and family in front of their store on Front Street. *Courtesy of South Park Historical Society.*

In May 1906, the operator of the Senate Saloon stepped into the back room about nine o'clock one evening, supposedly to get more of the liquor his patrons were drinking. He lit a match for some light, and an explosion immediately caused the room to break out in flames. It was thought that there was a leak in one of the gas pipes that had accumulated until the next visitor to enter provided the spark. The hose house being only a block away, the volunteers immediately responded, and the fire was confined to the two back rooms.

The next few years were fairly quiet, but a fire was discovered in early November 1909 in a building on Front Street owned by William Hill. The fire had originated in the kitchen, caused by a defective flue, and was discovered by Mrs. Hill, whose residence was next door. She had quickly rushed over with a garden hose, climbed the roof and had the fire mostly under control by the time the hose cart and volunteers arrived. The building survived, although there were numerous holes chopped in the roof to make sure that the fire was fully extinguished. The carpets and clothing in the closets were reportedly thoroughly drenched with the water used to put out the fire.

In 1911, a fire committee appointed by the town board investigated conditions that might cause a fire hazard throughout the town. They found that the Cohen building on the north side of Front Street constituted a danger, especially the exterior stairwell. They also reported on the advisability of remodeling the hose house. One Saturday afternoon late in June of that year, the men waiting to be shaved at Ed Rudd's barber shop were surprised by a loud crash and the sound of bricks falling against the building. As the fire committee feared, the side of the Cohen building next door had collapsed. One man who had been in the process of getting shaved in the barber's chair became so excited that he tore off the barber's apron, hastily donned his hat, grabbed his tie in one hand and his collar in the other and escaped to the center of Front Street, where he thought he was safer.

Samuel Cohen had moved to Denver but still owned properties in Fairplay. He hired a force of men to restore the building, originally built of adobe brick in 1874. The store building now boasted a cement sidewall and a concrete front walk.

GETTING MODERN

L et it be recorded! The first auto to make its appearance in Fairplay this season arrived near noon yesterday, " proclaimed the local newspaper on June 21, 1907. The writer went on to add that the auto in question found it necessary to visit the local blacksmith shop before it could proceed to its Buena Vista destination.

The first Fairplay citizens to take the plunge into auto ownership were Al Dollison and J.C. Singleton, the local bankers. Dollison purchased a Maxwell runabout, and Singleton brought home a large touring car in 1908. Herman Bergstrand, owner of the Metropole Livery, updated his business by adding a Maxwell touring car to offer to customers as an alternative to the usual horse-and-buggy.

In September 1907, a Denver investor started the process to equip the area with electricity by applying for a franchise. Although the service did not become widely available in Fairplay for another twenty years, the seed was nonetheless cast. The Central Colorado Power Company began to extend electric lines over Mosquito Pass and into Park County in 1910.

Early in 1911, a library club was formed. Several of the local businessmen, who were also on the town board and its committees, offered to make available the upstairs of the hose house for use as a library. The official opening of the library was celebrated with a program including singing, speeches and refreshments.

However, it was noted in 1916 that the library club moved their books and fixtures into the Odd Fellows building, across Front Street and down the

block. The club had also purchased a brand-new Whitney player piano that was installed in their new quarters.

The year 1917 brought news of a distant war, which most Americans tried to ignore and urged the country's leaders not to get involved. This became impossible when American ships began to be attacked. President Woodrow Wilson, despite his promises to stay out of the war, was forced into the fray and began enlisting the nation's young men to fight. Fairplay's young men were no exception. Their first experiences in World War I were, no doubt, exciting as well as frightening, as they were sent to Camp Funston, Kansas, for basic training. The town was saddened when it was reported that, "Frederick Henry Hammond, the first boy called to the army from this county, died of pneumonia at Camp Funston."

During the years of World War I, politics were so fractious that the local newspapers split into the *Park County Republican* and the *Fairplay Flume*. Both printed essentially the same local news, but political views differed radically. After the end of the war, the newspapers found that there was not enough local income for them both, so they again combined into a single newspaper, the *Park County Republican and Fairplay Flume*.

The Windsor Hotel, formerly known as the Bergh House, had been operated under a number of different owners and operators over the years

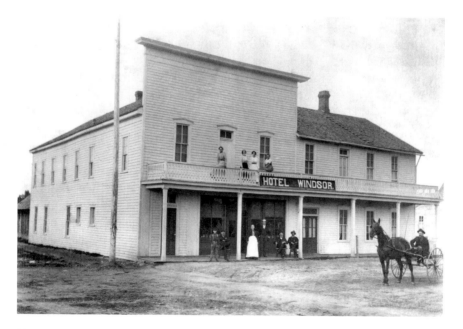

Hotel Windsor. *Courtesy of South Park Historical Society.*

since the late 1800s. In July 1921, a defective kitchen range created a very hot fire that spread to the entire building and its contents. The hotel was burned to the ground. The owner, Mrs. Agnes Slater, immediately began to make plans to build a new hotel.

By October of that year, the cement work was completed. An announcement appeared in the June 9, 1922 Fairplay *Flume* that "with the Chamber of Commerce dance, the new hotel will open its doors to the public." The Davis Bros. hall advertised the dance, which featured an orchestra from Colorado Springs and supper at the new hotel, located next door. This was the same hall built by the Fairplay Town Hall Association in 1880. The hall had evolved into a theater as well as a dance hall and was a public gathering place for many of the town's citizens. In 1923, the clientele of the Fairplay Theater, as it had become known, was apparently getting a bit too rowdy, prompting the town board of trustees to issue a warning that if the drinking and disorderly conduct on those premises did not cease, the license to conduct that business stood in danger of being revoked. The problem must have been solved, as the theater continued operations until mid-August of 1930. Then, during the wee hours one morning, a fire started. Volunteer firefighters were unable to save any of the theater building but kept the fire from spreading to the nearby hotel.

Hall owner Walter Davis soon began to rebuild. The theater was completed the following year, and picture shows were resumed with admission prices of fifteen and thirty-five cents. In later years, the locals were able to enjoy a bowling alley and a roller-skating rink as well. The theater became known as the Placer Theater, and a snackbar was featured.

The stock market crash in October 1929 sent the country into a depression that was to last a number of years. There was little reaction in the small town of Fairplay. An editorial in the October 23, 1931 newspaper proclaimed:

No Depression Here

Fairplay is one of the few mountain towns where the prevailing depression has not stopped building and improvements.

Within the past year there has been erected an up-to-date $20,000 hospital by Dr. Frank Dunkle.

The Cohen boys have rebuilt the old Cohen Store, now occupied by R.J. Steinfeld; the old front has been entirely removed and replaced by a very modern plate glass structure, hardwood floors, a Baker Electric

Refrigerating plant, celotex ceiling, new store fixtures and numerous other minor improvements.

A much needed hall for dances and talkies built by Walter Davis.

A new hotel on Front Street built by the Hands...

Late in 1934, a log cabin located on the eastern edge of town was discovered to be ablaze one Friday evening. The hose cart arrived in time to save the walls, but the contents were a total loss. An overheated stove was thought to be the cause.

Although relatively little damage was done and very few people were even aware it had happened, the fire caused the editor of the newspaper to start a campaign. His condemning statement, "The hose cart has not found its way back to the hose house but is reposing on a vacant lot opposite the newspaper office," was a wake-up call to the local town officials. A public meeting was called in the county courthouse to discuss the creation of what was to become the Fairplay Volunteer Fire Department. Able-bodied men were recruited for membership, and a constitution and by-laws were written and accepted.

A siren was purchased and installed on a telephone pole on Front Street. Arrangements were made with the telephone office to relay any information about reported fire emergencies. The siren was to be sounded promptly at noon each day for exactly six seconds to test the signal. Any blast longer than that was to be regarded as an emergency call. It wasn't long before another siren was ordered that could be clearly heard for over a mile.

A new fire wagon was built—a four-wheel trailer bearing ladders on the side and a large equipment box. The box was designed to contain the firemen's hats and slickers, a folded hose, chemical equipment, axes, other small equipment and a trailer hitch. In the event the fire siren went off, some volunteer with a car or truck had to rush to the hose house and attach the fire wagon to his vehicle before departing to the scene of the fire.

Fire department officers became proactive in the promotion of their cause. They began to have annual dances that served as fundraisers and devoted to a mission of public awareness. One of their primary issues was to purchase a fire truck. Donations from the local community enabled them to order a new Chevrolet 157-inch-wheelbase truck from the Fairplay Motor Company, to be delivered about two weeks before Christmas in 1936. The "fire boys" would then build a bed on it and equip it for use. The fire department continued to have annual fundraising dances to raise money for their operations.

1937 Fairplay firetruck. *Courtesy of Tim Balough.*

Nationwide, the Depression continued to cause massive unemployment. President Franklin Roosevelt started a plan to try to bolster employment. It was originally called the Works Progress Administration (WPA), part of the New Deal, and was designed to jump-start a lagging economy. The town board applied for a WPA grant to build a town hall to replace the aging hose house.

The WPA program was designed to employ unskilled workers, so as not to anger unions, whose workers were deigned to be "skilled laborers." The cost to the town was to be $3,000 for materials, while the WPA program would expend $6,500 for labor.

Local businessmen Norman Hand and Dewey Dutton were assigned the task of drawing up plans for the new structure, which was to contain eleven rooms and a basement. The building would accommodate the fire department's equipment, a meeting room for the town board and a number of rooms for county offices, which were costing Park County about $1,800 a year. The new building would provide those offices at a lesser cost, saving the county several hundred dollars annually while also providing quarters for the town operations. The old hose house was demolished and the new Town Hall built in its place, expected to be ready for occupancy by July 15, 1938. It became a reality a mere ten days later than scheduled.

Meanwhile, new and different problems reared their heads.

Resurfacing Front and Main Streets called for an alteration of the main road leading to Alma. In 1936, the contract was let, and the road leading

Fairplay Town Hall. *Photo by author.*

north, no longer Front Street but the more direct Main Street, became much smoother and easier to navigate. An unwanted side effect was "law-defying speeders and disgraceful habitual drunkards," who put their own and everyone else's life at jeopardy. Motorists commonly sped through town at speeds of sixty miles per hour. The town board authorized fines of fifty dollars and extended visits to the town jail for habitual offenders.

An additional deterrent was proposed. The town board decided to provide police motor vehicles with sound equipment. Speeders would then find themselves pursued and overtaken by "an uncanny howl," much like the piercing shrieks of the siren on the new fire truck. "The fast boys had better look out," said one of the town officers. "We are more anxious to take away driving privileges before accidents than to bury the results afterwards."

TOWN BURROS

K nown as donkeys east of the Mississippi River and burros west of that dividing line, the sturdy little pack animals have been in North America for about five hundred years. Their origin is reputedly in Egypt, where they were domesticated and used as long ago as 4000 BC. Then, Christopher Columbus, on his second voyage in 1495 to the "New World," brought four jacks and two jennies to use for breeding stock. Burros were used as pack animals, but when mated with a horse, their offspring resulted in a mule that was a larger animal, stronger and adaptable to farm work. It was necessary to keep the burros for breeding stock because a mule is generally sterile.

Miners almost universally used burros for packing supplies in and ore out, as the long-eared, dun-colored critters were especially fitted to the mountain terrain with their small, sure-footed hooves and their ability to carry extremely heavy loads. Their unique personalities, as well as those of the hardy miners they accompanied, were subjects of many a yarn passed through generations. They were often referred to as Rocky Mountain Canaries, a tribute to their long and loud brays.

There is a monument on Front Street to commemorate one of Fairplay's most famous burros, Prunes. Rupert Sherwood, a miner who prospected for gold in the late 1800s, partnered with Prunes after purchasing him in Alma for ten dollars. It was told that Rupe could send Prunes into town with a grocery list attached to his pack, the grocer would assemble the items and the faithful burro would dutifully carry them back to the mining camp. Prunes, an extremely social burro, made the rounds of

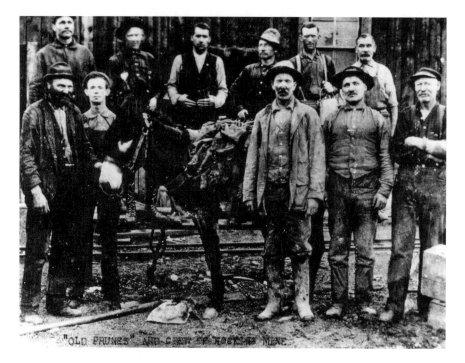

Prunes at the Hock Hocking Mine. *Courtesy of South Park Historical Society.*

local businesses when in town and was affectionately given biscuits and his personal favorite—flapjacks.

Rupe gave up mining and turned Prunes loose in the late 1920s. It was a usual occurrence for miners to release their burros for the winter and then reclaim them in the spring when warmer weather allowed them to work their mines. Many of the local school children would lay claim to a burro and keep it over the winter, riding it to school and home and making sure it was fed.

In 1926, the local school reported that the town donkeys had been serenading the high school every afternoon. Teachers remarked that it was to be hoped that the pupils would be as enthusiastic as their four-legged friends during their weekly Wednesday assembly.

During the winter of 1930, Prunes roamed around town as usual, begging at his favorite locations. But after a while, people began to notice that Prunes was not making his usual rounds. A search began, and the elderly burro was finally found in a shed in which he had found shelter during a winter storm. The door of the shed had blown shut, however, and Prunes was trapped inside.

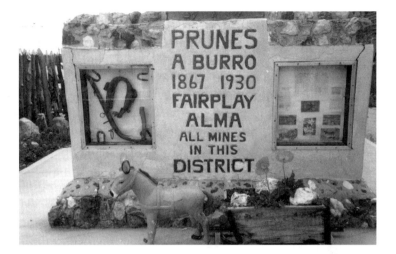

Prunes Monument on Front Street. *Courtesy of South Park Historical Society.*

Weak from hunger, Prunes was fed, but due to his age and general feeble condition, the townspeople decided that it would be kinder to put him out of his misery. So Prunes was mercifully shot, and plans were immediately put into effect to erect a monument in his memory, near which his remains would be interred. The monument was installed next to the Blue Bell Diner in Fairplay on Front Street, and the ceremony warranted mention in the *New York Times* on May 19, 1930.

Rupe, who was not in good health either, had mentioned that he would like to be buried near his faithful partner. He developed an infection in his foot and died at the Fairplay Hospital in August 1931. As per his wishes, his ashes were placed near the Prunes monument.

The story doesn't end there, though. The World War that erupted in the early 1940s caused a chain reaction from the *Rocky Mountain News*, to Fairplay local businessman and president of the Fairplay Chamber of Commerce Jack Ahern, and to the Royal Canadian Air Force (RCAF), resulting in the gift of the wiry little grandson of Prunes, dubbed Prunes II, to the RCAF as a mascot.

The young burro, said to be the spittin' image of his grandsire, visited Denver's City Park and a Denver orphans' home before he completed his journey to Alberta, Canada, in 1943. Prunes II was given a commission equivalent to that of a first lieutenant, at which rank he eventually retired to finish his days on a ranch with plenty of pasture.

Prunes II left behind a Prunes III, who was also to play a part in the community commitment to the war effort. The Fairplay Chamber of

Commerce had spearheaded collections amounting to $1,000 for the War Chest Committee and felt strong competition from other surrounding counties to show their patriotism. The committee had the money changed into silver dollars and loaded them into a small ore wagon. Prunes III was transported to Denver and hitched to the ore wagon, which he hauled up the steps of the State Capitol, where Governor Vivian accepted the donation amidst much publicity.

Later, an auction for Prunes III was held, and the winning bid of $200 was offered by the Lindner Packing Co. The proceeds were added to the War Chest, and the burro was then donated to the Queen of Heaven Orphanage in Denver. A thrilled five-year-old girl was lifted onto the back of the orphans' new pet as the transaction was completed.

Shorty was another of the local burros who had been used by the miners but turned loose when mining activity dwindled. Given his name because of the length of his legs, Shorty could be nonetheless just as stubborn as his fellow burros. He, too, was growing old and losing his eyesight. One day in 1949, a strange-looking dog appeared in town. The dog was white with black spots, perhaps part Dalmatian. He and Shorty found one another in a pasture on the edge of town as they snuggled together for warmth one night. Thus began their legendary friendship.

The dog became known as Bum, and local residents often saw the two making their rounds together as they looked for handouts. Bum would lead the way, usually making a stop at the Hand Hotel, where Maizie the cook saved biscuits and pancakes for them. Johnie Capelli, janitor at the courthouse, took to parking his car outside so that the burro and dog could curl up on bales of hay in his garage when the weather was cold. He even let them into the heated county jail some nights, hurrying to clean it up in the morning before the sheriff came in.

Then, one day in 1951, Bum took off after a chipmunk across the street. Shorty attempted to follow him but was quite blind by that time and didn't see the speeding driver, who hit him broadside and then drove off. When Bum tired of his chipmunk chase, he returned, but he couldn't find his friend. He instead followed the pool of blood in the street to the local dump, where the locals had dragged the carcass of the burro. Bum guarded the body for days, snarling at anyone who tried to come near. Finally, the locals decided to burn the burro's body. Bum hung around, but later that same year, he suffered the same fate and was hit and killed by a speeding auto. The remains of the blind burro and the mongrel dog were buried together, and a monument was again erected in the Town of Fairplay in the memory of the beloved animal friends.

GOLD DREDGE TO GOLD DAYS

E ven as hydraulic mining faltered, hopes of working the gravel for the gold that remained were revived when more sophisticated equipment was developed. In 1925, attempts were made to begin dredging operations. A small dredge began scooping the waters of the South Platte River south of town to retrieve the gold from the gravel. Ranchmen who lived below the workings began to notice discoloration of the water. Although the dredge company attempted to explain that dredge operations were different from hydraulic mining and that the discoloration was not polluting the water but merely stirring up the gravel, skepticism remained.

The explanations were marginally accepted, and the dredge company may have been able to come to an agreement with the ranchers, but the possibility of having to fight legal battles outweighed the benefits and the operation did not go forward.

In 1940, interest in dredging operations was revived. The price of gold, which was at $20 an ounce when the first dredge boat was operated near Fairplay, had risen to $35 an ounce. The South Platte Dredging Company began to look at gold dredges again. The company had gained approval of a $750,000 loan from the federal government but opted instead to sell half of their capital stock to a California investment firm for that amount when they discovered that federal money meant government supervision of their operations.

The dredge built with that investment was an all-steel boat, 155 feet long and 58 feet wide, weighing 2,300 tons. It could operate to a depth of 70 feet

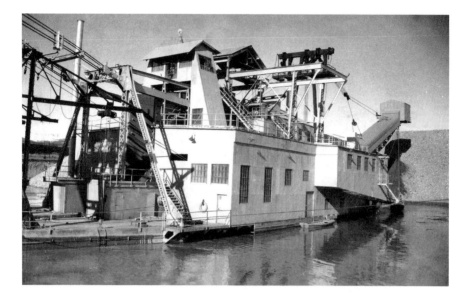

Postcard of So. Platte Dredge. *Courtesy of South Park Historical Society.*

below the water level and had the capacity to handle 14,500 cubic yards of gravel every twenty-four hours. It was explained that, "A placer mining dredge carries its lake with it, digging out in front and filling in behind." The dredging company excavated a lake 275 by 300 feet on the surface and 15 feet deep. The dredge was equipped with 103 buckets that dug under water into the gravel one after another and revolved to the top of the dredge, at which point the contents of each bucket was dumped onto a moving trommel screen. Smaller rocks along with the gold dropped through the screen and were conveyed through sluice boxes, where the gold was extracted. Rocks too large to go through the trommel screen were carried to a stacker, which then deposited them behind the dredge. Once a week, the operation was stopped so that the sluice boxes could be cleaned and the gold recovered. The gold was then transported to the mint in Denver.

The dredge went "full steam ahead" during 1941; however, when war was declared after the December 7 attack on Pearl Harbor, the War Production Board declared a ban on all gold-mining operations.

As young men were drafted into military service, those at home endured rationing of all types. Sugar, gasoline and tires were but a few of the items whose purchase was limited by a system of coupon distribution and redemption.

The local newspaper sadly reported in September 1943 that Lieutenant Merle F. Tompkins, a Fairplay High School graduate, had been killed while

on a mission with the Royal Air Force over the English Channel. Tompkins had been trained as a bomber pilot and was flying planes from his assigned ship, *Liberator*, when the mishap occurred.

Lieutenant Colonel John D. Tolman, a Fairplay native and a graduate of the Colorado School of Mines, was featured in the local news in 1944. A Chemical Warfare Service officer, Tolman helped develop a 4.2-inch mortar that proved to be a devastating weapon against the Japanese in the Southwest Pacific.

In 1945, Sergeant Norman B. Snell, of Alma, was awarded the Bronze Star Medal for his heroism during military operations in Germany. Snell and four other men were given the job of clearing a road so that U.S. tanks could get into a well-fortified German town. Under heavy mortar fire, the five infantrymen got down on hands and knees and probed the road for mines, leaving it clear for the tanks to proceed.

Lieutenant Norris Echternacht, who had worked a while for the Fairplay Drug Store, was reported to be a prisoner of war in Germany. In August 1944, he and several others had been forced to abandon a plane over the Adriatic Sea after an Allied mission to bombard the Ploesti oil fields in Romania. Echternacht was last seen floating in the sea in a life vest, and the War Department told his parents that he had been captured by the Germans. In April 1945, his surprised parents received a letter from him declaring that he had escaped.

After victory was sure on all fronts, the War Production Board announced that the ban on gold-mining operations would be lifted on June 15, 1945. The South Platte Dredging Company lost no time in resuming dredging operations at their Fairplay site. Former employees were contacted, including discharged war veterans, and the town began to recover from its war depression.

The town again became accustomed to the noise and flickering of their electrical power caused by the monster boat that was extracting treasure from its gravel. The story was told of Superintendent Webb Skinner, who was walking the gang plank to shore one day, carrying a coffee can full of gold, when he slipped and dropped the can into the water. Skinner stopped the dredge and had the boat backed up to where he had dropped the nuggets. He later claimed to have recovered just about all of the gold that was in the can.

In 1947, local businessmen got together to organize a Gold Days celebration and a rodeo. The town celebration would also include a carnival, a parade and several dances. Enjoying success, the Gold Days celebration was renewed the next year. In 1948, an air show (including a parachute

demonstration), a beauty contest and a burro baseball game were added to the list of activities.

By 1949, the Gold Days celebration had begun to attract wide attention. The Fairplay Chamber of Commerce was organized to promote the area and began to look for other attractions to bring attendees to the annual Gold Days event. Other new events added to the program were horse races and a motorcycle hill climb. The *Rocky Mountain News* in Denver agreed to sponsor a pack burro race from Leadville across Mosquito Pass to Fairplay, a rugged twenty-two-mile trek. The event was tentatively named "The Rupe and Prunes Pack Burro Derby." The name was later changed to the "First Annual Rocky Mountain Pack Burro Championship Race."

A $500 purse was guaranteed the human winner of the burro race, and tickets were sold to guess the winning time. Challenges were issued to nearby mining towns for their burro race teams to enter the contest. Rules of the race were published as follows: Participating burros will carry a pack saddle weighing a minimum of 33 pounds. Burros will be led by a halter with a rope attached not to exceed 15 feet. Burros will be examined by a veterinarian to verify their

Burro teams start through museum in the 2010 race. *Photo by author.*

qualifications. (Mules would not be allowed.) The winning team will be established as the one whose burro's nose crosses the finish line first.

On the day of the race, twenty-one pairs of contestants lined up in front of the Leadville courthouse. At the pop of the starting gun, burros and men took off. It wasn't long before some of them began to fall back. The two leaders were Melville Sutton with Whitey, Como's entry, and Ed Knizely with Prunes IV, sponsored by the Fairplay Chamber of Commerce. As the leaders came into sight of the finish line at the Prunes Monument on Front Street in Fairplay, Sutton regrouped and broke into a run to finish first. Knizely was hindered by a pronounced limp but finished second, insisting that Prunes IV was the superior burro but was held back by his own leg injury.

The winning time was 5 hours, 10 minutes, 41.2 seconds.

The Pack Burro Championship Race became the focal point of the annual celebration thereafter, and the two-day event on the last weekend in July continues to be an annual Fairplay attraction more than sixty years later.

SOUTH PARK CITY

A fter several years of successful gold extraction—more than $3 million worth—the South Platte Dredging Company announced that 1951 would be its last year of operations. The piles of rock tailings at the south end of town remain to mark that era, but the sound of heavy buckets dropping loads of rock onto the Fairplay Dredge was silenced.

By this time, the local businessmen had figured out that the key to prosperity in a small mountain town was that emerging phenomena—tourism. The traveling public, which had responded to the publicity of Gold Days and burro races, was also interested in the history of the early days, when gold miners eked out a living and braved the wilderness.

Fairplay citizens noticed that nearby "ghost towns" were revived and brought curious onlookers to see "how it was back then." The Fairplay Chamber of Commerce, whose members had worked tirelessly to ensure the success of Gold Days and the burro races, looked around and saw visions of their own "ghost town."

They were encouraged by the announcement of the Colorado Centennial Commission, which had begun a massive campaign to hold events throughout the state, establishing a calendar of events for their "Rush to the Rockies." The centennial, scheduled for 1959, was to celebrate one hundred years since the gold discovery in Colorado.

The focal point in Fairplay became a building that had sat empty for a number of years but represented a unique part of the town's history. The Summer Brewery had turned out barrels of South Park Lager beer before the

turn of the twentieth century but had since fallen into disrepair, serving as a storage building for just about anything. Several other buildings in the same general vicinity were also sitting empty, deteriorating year by year. The Summer Saloon, the Summer residence and the house across the road where the famous buffalo hunter Frank Mayer had lived for years all suggested possibilities.

The members of the Fairplay Chamber of Commerce came up with the idea of a "Way of Life Museum." In 1957, the South Park Historical Society was founded and incorporated and a board of directors elected. In 1958, the South Park Historical Foundation was also incorporated. When locals questioned why there were two entities, it was explained that the society owned all the personal property for the museum and that the foundation owned all the real property.

Whatever the legal details were, the project was hugely supported by the editor of the *Park County Republican and Fairplay Flume*, Chester "Chet" Mariner. Chet lost no opportunity to advertise, chastise, cajole and otherwise encourage community involvement in the museum. Hardly a weekly edition went by without some mention of the town's museum project and the public's responsibility to support it.

One of the first organizations to become involved was the Methodist Historical Society. Their Father Dyer Church was to be moved from Front Street to the narrow "Y" across Main Street from the museum buildings. The Methodist group also planned to build a road to the old Fairplay cemetery nearby where a few graves remain. The church was later moved again to a spot in back of the brewery.

Meanwhile, an office had been set up in the brewery to conduct business and accept donations of historic treasures to be displayed. The South Park Lions Club had taken on the tasks of laying floors in the brewery and general cleanup of the building. They reported that they had gotten together on a Friday evening in April 1958 to work on their project. In the process of nailing down flooring, one of the enthusiastic workers had inadvertently nailed himself to the floor. When the hour became late, the enthusiastic worker discovered his plight, and lest he be deserted for the night, "he let out a yowl that would have put old Shorty the Burro to shame." The others came to his rescue and used a pinch bar to get him loose.

The members of the society felt that a disturbing number of community citizens were satisfied to sit back and let everybody else work on the project while they waited for the benefits that would come to them when it was done. So they came up with a novel idea. Since "Let George Do It!" seemed to be the attitude, a mock funeral was organized to bury "George."

The funeral procession was scheduled for Friday, May 2. Local businesses were encouraged to close up shop for the hours between 2:00 and 4:00 p.m. and attend the "somber" ceremony. The procession began at the old coffin shop located in the back of the Bank of Fairplay on Front Street. A shoebox-type coffin was carried out to the old Como horse-drawn hearse, and thence the procession made its way to the Father Dyer Church on Front Street (which hadn't been moved to its new location yet). The funeral service was held there, and then the mourners made their way to the brewery, where the "remains" were entombed in the basement of the building under a concrete floor, which was scheduled to be poured that day. The burial was highly publicized, and all residents of Fairplay were given to understand that this was their project and that they could no longer "Let George Do It."

The first building to be moved into the "Way of Life" town came from Lake George. It had first been used as a saloon and was later remodeled for use as a school building until a new school was built there. In its new home, the building became the *South Park Sentinel* building, a newspaper named after the original one in Fairplay.

It became official. The town was named South Park City, as it had been called before the name Fairplay was adopted.

Eight more buildings had been identified for moving into the historic town: General Store, Saloon, Silverheels Dance Hall, Carpenter Shop, Chinese Hall, Assay Office and School House. The Singleton family donated the old Bank of Alma and an adjoining building in Alma, originally used as a feed store, which was to become the Drug Store in the new town.

The Merriam family from Westcliffe had been in the druggist business during the 1880s and had stored all of the old pharmaceutical items in a basement, unused for years. These were all brought to the museum, where they continue to be one of the most complete displays of pioneer drugstore items to be found. A soda fountain used at the Hartsel Mercantile was donated by the Kleinknecht family and installed in the museum drugstore.

Frank Turner, an old-timer from Garo whose family had owned and run the Garo Store, donated a log building that, when moved to South Park City, became a display of pioneer laundry facilities. The School House, originally built in the 1880s, also came from Garo.

It was reported that local grocer Bob Pocock "grudgingly" gave up a landmark from behind his store. The outhouse was moved to a spot near the Garo school.

The Central Colorado Cattlemen's Association took on the restoration of the Star Livery. They first had to straighten and brace the building, after

which they furnished it with harnesses, bridles, wagons, sleighs and other equipment reminiscent of the era.

A few months before the museum was scheduled to open, the town council agreed to the closing of Front Street through South Park City. A fence was installed to enclose the historic properties, and the society decided that nominal fees must be charged to cover expenses. The cost was to be fifty cents for adults and twenty-five cents for children.

An official post office was established in the General Store, and visitors could have their mail sent with the South Park City cancellation.

Two Denver radio stations, KHOW and KOA, conducted special broadcasts to give South Park City publicity and encourage visitors to come to the new museum. The monumental undertaking was well on its way to a success story.

Since the 1959 opening, many new displays have been added and the old ones improved. The South Park City Museum continues to draw thousands of visitors to Fairplay each year throughout the summer season.

The question might be asked, what caused some early towns to close down and decay away and others to grow and become successful? There may be a

South Park City Museum entrance gate. *Photo by author.*

lot of reasons, but a poem published in the *Park County Republican* on March 2, 1917, offers one:

IT ISN'T THE TOWN, IT'S YOU

If you want to live in the kind of a town
Like the kind of town you like,
You needn't slip your things in a grip
And start on a long, long hike.

You'll only find what you left behind,
For there's nothing that's really new.
It's a knock at yourself when you knock your town,
It isn't the town, it's you.

Real towns are not made by men afraid
Lest somebody else gets ahead;
When everyone works and nobody shirks,
You can raise a town from the dead.

And if while you make your personal stake,
Your neighbor can make one too,
Your town will be what you want to see—
It isn't the town, it's YOU.

BIBLIOGRAPHY

CHAPTER 1

Chronic, Halka, and Felicie Williams. *Roadside Geology of Colorado*. Missoula, MT: Mountain Press Publishing Company, 2002.

Foutz, Dell R., PhD. *Geology of Colorado Illustrated*. Grand Junction, CO: Your Geologist, 1994.

Hafen, LeRoy R., PhD, and Ann W. Hafen. *Colorado: A Story of the State and Its People*. New York: Lewis

Historical Publishing Co. Inc., 1948.

McGookey, Donald P. *Geologic Wonders of South Park, Colorado*. Midland, TX: Donald P. McGookey, 2002.

Pearl, Richard M. *Exploring Rocks, Minerals, Fossils in Colorado*. Chicago: Sage Books, 1964.

Voynick, Stephen M. *Colorado Gold*. Missoula, MT: Mountain Press Publishing, 1992

————. *Colorado Rockhounding*. Missoula, MT: Mountain Press Publishing, 1994.

Wicander, Reed, and James S. Monroe. *Historical Geology*. Pacific Grove, CA: Brookes/Cole Publishing, 2000.

Internet Sources

University of Colorado Geological Studies. "Colorado Mineral Belt." http://www.colorado.edu/GeolSci/Resources/.

Wikipedia.org. "Geology of the Rocky Mountains." http://en.wikipedia.org/wiki/Geology_of_the_Rocky_Mountains.

CHAPTER 2

Hafen, LeRoy R., PhD, and Ann W. Hafen. *Colorado: A Story of the State and Its People*. New York: Lewis Historical Publishing Co., Inc., 1948.

Pettit, Jan. *Utes: The Mountain People*. Boulder, CO: Johnson Printing Company, 1990.

Rockwell, Wilson. *The Utes: A Forgotten People*. Boulder, CO: Western Reflections Inc., 1956

Simmons, Virginia McConnell. *Bayou Salado: The Story of South Park*. Boulder: University Press of Colorado, 2002.

————. *The Ute Indians of Utah, Colorado, and New Mexico*. Boulder: University Press of Colorado, 2000.

CHAPTER 3

Abbott, Carl, Stephen J. Leonard and Thomas J. Noel. *Colorado: A History of the Centennial State*. Boulder: University Press of Colorado, 2005.

Ambrose, Stephen E. *Undaunted Courage*. New York: Simon & Schuster, 1996.

Calkins, Carroll C., ed. *The Story of America*. Pleasantville, NY: Readers' Digest Association Inc., 1975.

Hafen, LeRoy R., PhD, and Ann W. Hafen. *Colorado: A Story of the State and Its People*. New York: Lewis Historical Publishing Co., Inc., 1948.

Simmons, Virginia McConnell. *Bayou Salado: The Story of South Park*. Boulder: University Press of Colorado, 2002.

Ubbelohde, Carl, Maxine Benson and Duane A. Smith. *A Colorado History*. Boulder, CO: Pruett Publishing Company, 1972.

Internet Sources

TheGeoZone.com. "A General History of Colorado." http://www.thegeozone.com/treasure/colorado/history/index.jsp.

Wikipedia.org. "Francisco Vasquez de Coronado." http://en.wikipedia. org/wiki/Francisco_Vasquez_de_Coronado.

———. "Hernan Cortes." http://en.wikipedia.org/wiki/Hernan_Cortes.

———. "Juan de Onate." http://en.wikipedia.org/wiki/Juan_de_Onate.

CHAPTER 4

Abbott, Carl, Stephen J. Leonard and Thomas J. Noel. *Colorado: A History of the Centennial State*. Boulder: University Press of Colorado, 2005.

Calkins, Carroll C., ed. *The Story of America*. Pleasantville, NY: Readers' Digest Association Inc., 1975.

Dary, David. *The Oregon Trail: An American Saga*. New York: Alfred A. Knopf, 2004.

Egan, Ferol. *Fremont: Explorer for a Restless Nation*. Reno: University of Nevada Press, 1977.

Farnham, Thomas J. *Travels in the Great Western Prairies: The Anahuac and Rocky Mountains, and in the Oregon Territory*. New York: Wiley & Putnam, 1843.

Hafen, LeRoy R., PhD, and Ann W. Hafen. *Colorado: A Story of the State and Its People*. New York: Lewis Historical Publishing Co., Inc., 1948.

Preuss, Charles. *Exploring With Fremont*. Norman: University of Oklahoma Press, 1958.

Roberts, David. *A Newer World*. New York: Simon & Schuster, 2000.

Ruxton, George Frederick. *Adventures in Mexico and the Rocky Mountains*. New York: Harper & Brothers, 1848.

Sage, Rufus P. *Scenes in the Rocky Mountains*. Glendale, CA: The Arthur H. Clarke Company, 1846.

Simmons, Virginia McConnell. *Bayou Salado: The Story of South Park*. Boulder: University Press of Colorado, 2002.

Ubbelohde, Carl, Maxine Benson and Duane A. Smith. *A Colorado History*. Boulder, CO: Pruett Publishing Company, 1972.

Internet Sources

History1700s.com. "The Zebulon Pike Expedition of 1806/07." http://www.history1700s.com/articles/article1152.shtml.

The Napoleon Series. "Treaty of San Ildefonso." http://www.napoleon-series.org/research/government/diplomatic/c_ildefonso.html.

Wikipedia.org. "Mexican War of Independence." http://en.wikipedia.org/wiki/Mexican_War_of_Independence.

————. "Pike Expedition." http://en.wikipedia.org/wiki/Pike_expedition.

————. "Rufus Sage." http://en.wikipedia.org/wiki/Rufus_Sage.

————. "Thomas J. Farnham." http://en.wikipedia.org/wiki/Thomas_J._Farnham

CHAPTER 5

Abbott, Carl, Stephen J. Leonard and Thomas J. Noel. *Colorado: A History of the Centennial State.* Boulder: University Press of Colorado, 2005.

Calkins, Carroll C., ed. *The Story of America.* Pleasantville, NY: Readers' Digest Association Inc., 1975.

Davis, Kenneth C. *Don't Know Much About History.* New York: Avon Books, 1991.

Foner, Eric, and John A. Garraty, eds. *The Reader's Companion to American History.* Boston: Houghton Mifflin Company, 1991.

Hafen, LeRoy R., PhD, and Ann W. Hafen. *Colorado: A Story of the State and Its People.* New York: Lewis Historical Publishing Co., Inc., 1948.

Ubbelohde, Carl, Maxine Benson and Duane A. Smith. *A Colorado History.* Boulder, CO: Pruett Publishing Company, 1972.

Internet Sources

Wikipedia.org. "Kansas-Nebraska Act." http://en.wikipedia.org/wiki/Kansas-Nebraska_Act.

————. "Kansas Territory." http://en.wikipedia.org/wiki/Kansas_Territory.

————. "Mexican-American War." http://en.wikipedia.org/wiki/Mexican_american_war.

————. "Nebraska Territory." http://en.wikipedia.org/wiki/Nebraska_Territory.

Chapter 6

Basyc, Charles P. "Fairplay in 1859." *Fairplay Flume*, March 10, 1910.

Davidson, Roy A. "Some Early Manuscript Records of Park County, Colorado, 1859–63." *Colorado Magazine* 18, no. 5 (September 1941).

Hafen, LeRoy R., PhD, and Ann W. Hafen. *Colorado: A Story of the State and Its People*. New York: Lewis Historical Publishing Co., Inc., 1948.

Smith, Duane A. *The Birth of Colorado: A Civil War Perspective*. Norman: University of Oklahoma Press, 1989.

Wallis, Mather C., and Russell A. Morse Jr. *A Short and Informal Early Days History of the Town of Fairplay*. Fairplay, CO: Centennial Times Publishing Co., 1975.

Internet Sources

Wikipedia.org. "Battle of Glorieta Pass." http://en.wikipedia.org/wiki/Battle_of_glorieta_pass.

———. "Colorado Territory." http://en.wikipedia.org/wiki/Territory_of_Colorado.

———. "Jefferson Territory." http://en.wikipedia.org/wiki/Territory_of_Jefferson.

———. "Kansas Territory." http://en.wikipedia.org/wiki/Kansas_Territory.

———. "Nebraska Territory." http://en.wikipedia.org/wiki/Nebraska_Territory.

Chapter 7

Agnew, Jeremy. "The Legend of the Lady in Gray." *Denver Post*, November 2, 1980.

Basyc, Charles P. "Fairplay in 1859." *Fairplay Flume*, March 10, 1910.

Bennet, H. "Statement to First Assistant Postmaster General." April 3, 1862.

Buyer, Laurie Wagner. "The Buyer-Coil Ranch: Historic Ranch Dates to 1860." *Fairplay Flume*, August 13, 1993.

Conner, Daniel Ellis. *A Confederate in the Colorado Gold Fields*. Norman: University of Oklahoma Press, 1970.

Daily Colorado Republican and Rocky Mountain Herald. "Buckskin Joe, August 8, 1861." August 16, 1861.

Fiester, Mark. *Look for Me in Heaven.* Boulder, CO: Pruett Publishing Company, 1980.

Hall, Frank. *History of Colorado.* Chicago: Blakely Printing Company, 1889.

Rocky Mountain News Weekly. "Hinckley & Co.'s Express Advertisement." September 12, 1860.

————. "House Has Approved the Following Bills." August 15, 1862.

————. "New Store in Fairplay." June 7, 1862.

————. "Personal." October 9, 1862.

Internet Sources

Wikipedia.org. "Mount Silverheels." http://en.wikipedia.org/wiki/Mount_Silverheels.

CHAPTER 8

Bent, Ben. "The Legend of Fairplay." *Out West,* October 1873.

Fossett, Frank. *Colorado: A Historical, Descriptive and Statistical Work on the Rocky Mountain Gold and Silver Mining Region.* Denver: Daily Tribune Steam Printing House, 1876.

Hall, Frank. *History of Colorado.* Chicago: Blakely Printing Company, 1889.

Hill, Alice Polk. *Tales of the Colorado Pioneers.* Denver: Pierson & Gardner, 1884.

Wolle, Muriel Sibell. *Stampede to Timberline.* Chicago: Swallow Press Inc., 1949.

CHAPTER 9

Brown, Joe, and Lucy Brown. "Fairplay Ranger Station Cemetery, Fairplay, Colorado." Cemetery records, n.d.

Perkins, James E. *Tom Tobin: Frontiersman.* Monte Vista, CO: Adobe Village Press, 2005.

Secrest, Clark. "The Bloody Espinosas: Avenging Angels of the Conejos." *Colorado Heritage,* Autumn 2000.

Tobin, Thomas T. "The Capture of the Espinosas." Interview on March 23, 1895. *Colorado Magazine* 9, no. 2 (March 1932).

CHAPTER 10

Albertson, N. "Miners' Meeting." *Rocky Mountain News*, October 13, 1860.

Basyc, Charles P. "Fairplay in 1859." *Fairplay Flume*, March 10, 1910.

Colorado Springs Gazette. "Judge J.M. Castello, Obituary." May 25, 1878.

Fiester, Mark. *Look for Me in Heaven*. Boulder, CO: Pruett Publishing Company, 1980.

Moncrief, Laura Lee, and Nancy Morris Boyd. *Florissant, Colorado, Pioneer Cemetery: The Stories Behind the Tombstones*. Florissant, CO: Laura Lee Moncrief, 2009.

Park County Records. Grantee and Grantor Books, 1860–1868.

Simmons, Virginia McConnell. *Bayou Salado: The Story of South Park*. Boulder: University Press of Colorado, 2002.

———. *The Ute Indians of Utah, Colorado, and New Mexico*. Boulder: University Press of Colorado, 2000.

Smith, Duane A. *The Birth of Colorado: A Civil War Perspective*. Norman: University of Oklahoma Press, 1989.

Wallis, Mather C., and Russell A. Morse Jr. *A Short and Informal Early Days History of the Town of Fairplay*. Fairplay, CO: Centennial Times Publishing Co., 1975.

Water District No. 23. "Priorities of Water Rights for the Use of Irrigation." District Court Proceedings, 1912.

CHAPTER 11

Bowles, Samuel. *Across the Continent*. Ann Arbor, MI: University Microfilms Inc., 1966.

Fairplay Flume. "How Bross Mountain Was Named." March 11, 1880.

Hafen, LeRoy R., PhD, and Ann W. Hafen. *Colorado: A Story of the State and Its People*. New York: Lewis Historical Publishing Co., Inc., 1948.

Hatfield, Mark O. *Vice Presidents of the United States, 1789–1993*. Washington, D.C.: U.S. Government Printing Office, 1997.

Hollister, Ovando James. *Life of Schuyler Colfax*. New York: Funk and Wagnalls, 1886.

Lavender, David. *The Rockies*. Lincoln: University of Nebraska Press, 1981.

Rocky Mountain News. "The Colfax Party." September 3, 1868.

————. "Speaker Colfax on Indians." July 11, 1865.

————. August 8, 1868.

————. September 3, 1868.

————. September 4, 1868.

————. September 5, 1868.

————. September 28, 1868.

CHAPTER 12

Bartlett, Richard A. *Great Surveys of the American West*. Norman: University of Oklahoma Press, 1962.

Brewer, William H. *Rocky Mountain Letters—1869*. Denver: Colorado Mountain Club, 1930.

Evanoff, Emmett. *Colorado and the Four Great Geological Surveys of 1867 to 1878*. Greeley: University of Northern Colorado, 2009.

Hayden, F.V. *Annual Report of the United States Geological and Geographical Survey of the Territories Embracing Colorado*. Washington, D.C.: U.S. Government Printing Office, 1874. *Rocky Mountain News*. "South Park Items." May 6, 1869.

CHAPTER 13

Rocky Mountain News. "Summer Saunterings." July 29, 1870.

Schenck, Annie B. "Camping Vacation, 1871." *Colorado Magazine* 42, no.3 (1965).

Woodward, P.H. *The Secret Service of the Post-Office Department*. Hartford, CT: J.P. Fitch, 1882.

Chapter 14

Daily Rocky Mountain News. "Aiding the Fairplay Sufferers." October 8, 1873.

———. "Bonds and County Buildings in Park County." January 28, 1873.

———."A Card to Editors Rocky Mountain News." October 17, 1873.

———. "From Park County." March 6, 1873.

———. "Our Park County Letter." June 8, 1873.

———. "Stricken Fairplay." September 30, 1873.

Feister, Mark. "From the Fires of Hell, Fairplay Persevered." *Empire Magazine,* September 23, 1979

Gardiner, Harvey N. *Mining Among the Clouds.* Boulder: Colorado Historical Society, 2002.

Park County Deed Records. "South Park City to James Moynahan." January 7, 1873.

Rocky Mountain News. "Aid for Fairplay." October 1, 1873.

———."A Destructive Fire Visits the Mountain City." September 28, 1873.

———. "From Fairplay, Growth and Improvement." May 6, 1873.

———. "More Particulars of the Fairplay Fire." September 30, 1873.

———. "Park County: Spring Prospects, etc." April 1, 1873.

———. "Territorial Gossip." April 15, 1873.

———. "Transactions of the United States Land Office." January 31, 1873.

Smith, Duane A. *Horace Tabor: His Life and the Legend.* Boulder: University Press of Colorado, 1989.

Wallis, Mather C., and Russell A. Morse Jr. *A Short and Informal Early Days History of the Town of Fairplay.* Fairplay, CO: Centennial Times Publishing Co., 1975.

Chapter 15

Fairplay Flume. April 10, 1879, page 3.

———. February 19, 1880.

———. December 8, 1881, page 3.

———. July 13, 1882.

———. October 5, 1882, page 4.

———. February 6, 1914.

Fiester, Mark. *Look For Me in Heaven*. Boulder, CO: Pruett Publishing Company, 1980.

Hillhouse, J.N. "The Sheldon Jackson Memorial Chapel at Fairplay." *Colorado Magazine* 23, September 1946.

Rocky Mountain News. "Regarding a Telegraph Line to Fairplay." March 28, 1874.

———. "Two Mules on the Fly." October 14, 1874.

———. February 15, 1874, page 1.

Simmons, Virginia McConnell. *Bayou Salado: The Story of South Park*. Boulder: University Press of Colorado, 2002.

Valiton, Charles L. "Forty-Five Years in Colorado." *Silverton Standard*, July 4, 1925.

Wallis, Mather C., and Russell A. Morse Jr. *A Short and Informal Early Days History of the Town of Fairplay*. Fairplay, CO: Centennial Times Publishing Co., 1975.

Wilkin, Charles A. "Testimony at the Matter of the Priorities of Water Rights." September 16, 1912.

Wonder, Alice E. "China Town, at Fairplay, as it Was in Early Days." *Fairplay Flume*, 1950s.

CHAPTER 16

Fairplay Sentinel. December 30, 1875, page 2.

Hafen, LeRoy R., PhD, and Ann W. Hafen. *Colorado: A Story of the State and Its People*. New York: Lewis Historical Publishing Co., Inc., 1948.

CHAPTER 17

Colorado Chieftain. "Fairplay and Alma." June 27, 1878.

CHAPTER 18

Fairplay Flume. "Telegraphic Facilities." March 20, 1879.

———. "Telegraphic Facilities." April 22, 1880.

————. September 22, 1881.

Hafen, LeRoy R., PhD, and Ann W. Hafen. *Colorado: A Story of the State and Its People*. New York: Lewis Historical Publishing Co., Inc., 1948.

Poor, M.C. *Denver, South Park and Pacific Railroad*. Denver: Rocky Mountain Railroad Club, 1949.

Rocky Mountain News. "To the South Park." March 14, 1874.

Simmons, Virginia McConnell. *Bayou Salado: The Story of South Park*. Boulder: University Press of Colorado, 2002.

CHAPTER 19

Fairplay Flume. "The Fatal Trap." July 29, 1880.

————. "Shot By His Friend." January 29, 1880.

————. "Wind-up of the Murder Examinations." April 10, 1879.

Park County Republican and Fairplay Flume. "The Court That Never Adjourned." June 1, 1967; June 8, 1967; June 15, 1967.

CHAPTER 20

Denver Weekly News. "Fairplay, One of the Oldest Towns." January 5, 1889.

Fairplay Flume. "A Fine Building." July 28, 1881.

————. "Proclamation." June 24, 1880.

————. "Town Ordinances." April 20, 1882.

————. "Town Ordinances." May 24, 1883.

————. December 2, 1880.

————. October 20, 1881.

————. October 5, 1882.

————. January 4, 1883.

————. January 24, 1884.

————. June 7, 1888.

————. January 19, 1893.

————. September 13, 1894.

CHAPTER 21

Denver Weekly News. "Fairplay, One of the Oldest Towns." January 5, 1899.
Fairplay Flume. "Ended His Life." September 13, 1900.
————. "Notice of Administratrix." August 5, 1907.
————. "South Park Brewery." March 27, 1879.
————. "The South Park Brewery in Ashes." August 11, 1892.
Rocky Mountain News. "Summer's Death." July 15, 1883.

CHAPTER 22

Fairplay Flume. "A Fire Alarm." November 12, 1909.
————. "New Council Meets." May 5, 1911.
————. "Old Land Mark Gives Up Fight." June 23, 1911.
————. "The Placer Mining Co." June 29, 1900.
————. June 29, 1900.
————. February 6, 1903.
————. February 27, 1903.
————. March 18, 1904.
————. August 19, 1904.
————. December 30, 1904.
————. May 12, 1905.
————. May 26, 1905.
————. October 13, 1905.
————. October 20, 1905.
————. May 15, 1906.
Parker, Ben H., Jr. *Gold Panning and Placering in Colorado*. Denver: Colorado Geological Survey, 1992.
Voynick, Stephen M. *Colorado Gold*. Missoula, MT: Mountain Press Publishing Co., 1992.

CHAPTER 23

Fairplay Flume. "An Attempt is Being Made to Start a Library." January 27, 1911.

———. "Commercial Club Dance Ad." May 26, 1922.

———. "Electric Lights for Alma, Como & Fairplay." September 6, 1907.

———. "Electric Power and Light." March 11, 1910.

———. "Fairplay Fire Fighters' Second Annual Banquet." November 27, 1936.

———. "Fairplay to Have Talkies." September 18, 1931.

———. "Fire Department Orders New Siren." January 18, 1935.

———. "The Honor Roll." December 14, 1917.

———. "Interior of a Log Cabin Burned Out." November 16, 1934.

———. "Loud Electric Siren Now Ready." December 28, 1934.

———. "Metropole Livery Up to Date." July 10, 1908.

———. "New Town Hall Project." February 18, 1938.

———. "No Depression Here." October 23, 1931.

———. "The Old Town Hall Burns." August 15, 1930.

———. "Town Board Decides to Deal Sternly With Speeders." July 15, 1938.

———. June 21, 1907.

———. May 8, 1908.

———. February 17, 1911.

———. January 28, 1916.

———. October 5, 1917.

———. July 1, 1921.

———. October 21, 1921.

———. June 9, 1922.

———. November 20, 1936.

Internet Sources

Wikipedia.org. "Works Progress Administration." http://en.wikipedia.org/wiki/Works_Progress_Administration.

CHAPTER 24

Bjorklund, Linda. *Burros!* Hartsel, CO: Linda Bjorklund, 2006.

Fairplay Flume. "Fairplay Provides Burro for Air Unit." July 22, 1943.

———. "Fairplay School Notes." October 22, 1926.

———. "Prunes III Sold for $200 at Denver Monday." November 11, 1943.

———. "Prunes III to Haul War Chest Money." October 14, 1943.

Chapter 25

Bjorklund, Linda. *Burros!* Hartsel, CO: Linda Bjorklund, 2006.

Fairplay Flume. "All Set for Big 'Gold Days' Celebration." July 29, 1948.

———. "The Dredge: End of an Era." June 19, 1980.

———. "The Fairplay Gold Dredge." September 4, 1925.

———. "Gold Ban Order To Be Lifted." June 14, 1945.

———. "Gold Days and Rodeo in Fairplay." July 17, 1947.

———. "'Gold Days' Celebration Saturday and Sunday." June 16, 1949.

———. "Gold Dredge at Fairplay in Operation." August 2, 1945.

———. "Great Gold Dredge To Be Built." May 9, 1940.

———. "Lieut. Merle F. Tompkins Killed." September 16, 1943.

———. "Lt. Col. John D. Tolman." September 21, 1944.

———. "Mammoth Dredge Will Devour Sand of South Platte." May 8, 1941.

———. "Norris Echternact Escapes." May 24, 1945.

———. "Park County Boy is Awarded Bronze Star Medal." March 8, 1945.

———. August 4, 1949.

Chapter 26

Amitrani, E.J. "Gene." *A Town Is Born: The Story of South Park City.* Fairplay, CO: South Park Historical Foundation, 1982.

Fairplay Flume. "Everything Set for Burying George Friday." May 1, 1958.

———. "It's Time For An Explanation." August 7, 1958.

———. "Methodists Accept Job." March 6, 1958.

———. "Museum Buildings Being Moved In." May 15, 1958.

———. "Residents Agree to Close Front St." April 2, 1959.

———. "South Park City Opens This Friday." May 14, 1959.

———. "South Park City Post Office to Open." May 7, 1959.

———. "South Park Historical Society to Build Town." July 11, 1957.

Voynick, Stephen M. *Colorado Gold.* Missoula, MT: Mountain Press Publishing Company, 2002.